SCOTLAND

IN OLD PHOTO

KILMARNOCK
MEMORIES

FRANK BEATTIE

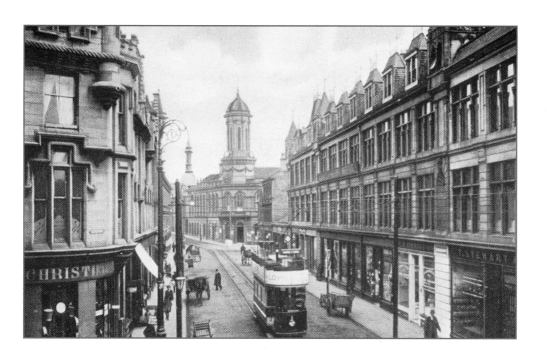

SUTTON PUBLISHING

Sutton Publishing Limited
Phoenix Mill · Thrupp · Stroud
Gloucestershire · GL5 2BU

First published 2003

Copyright © Frank Beattie, 2003

Title page photograph: Duke Street, *c.* 1905.
(*PC*)

British Library Cataloguing in Publication Data
A catalogue record for this book is available from the
British Library.

ISBN 0-7509-3236-8

Typeset in 10.5/13.5 Photina.
Typesetting and origination by
Sutton Publishing Limited.
Printed and bound in England by
J.H. Haynes & Co. Ltd, Sparkford.

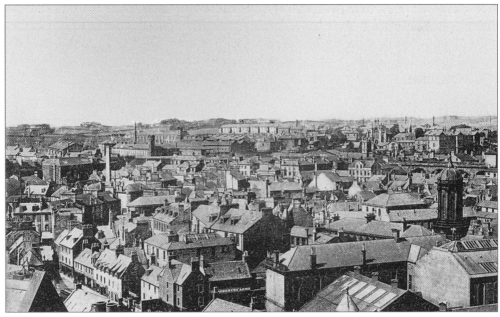

Townscape from the tower of Kilmarnock Academy, *c.* 1904. (*PC*)

CONTENTS

This book is dedicated to my father, Frank Beattie (1918–59).
I never had a chance to know him.

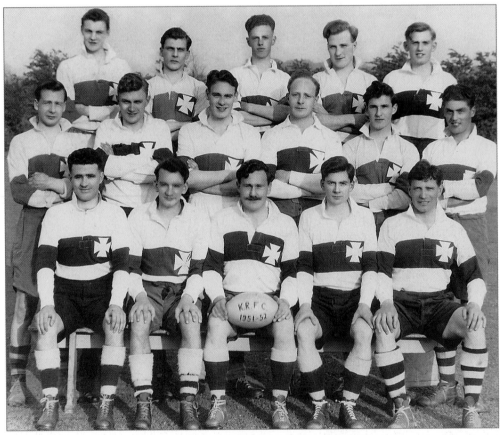

The Kilmarnock Rugby Football Club second XV team of 1951/2. In that season they played 19 games, won 16, lost 2 and drew 1. They took 293 points and lost 52. Back row, left to right: Ironside, White, Fulton, Cree, McKnight; middle row: Livingston, Wilson, McFarlane, Pirret, Millar, Kelso; front row: Andrew, McCrae, Maxwell (captain), Inglis and Beattie (the author's father). (*Author's Collection*)

INTRODUCTION

FROM SLEEPY HAMLET TO THRIVING TOWN

No one knows when Kilmarnock began to be established. Long ago, before recorded history, men lived in scattered communities, mostly on the coast, but also inland, near important rivers. Such nomads might have been the first to settle near Kilmarnock, not that it was named as such then.

The Romans came to this part of the world in AD 79. The land they called Caledonia was at the extremity of their vast empire and unlike the land to the south, the people of Scotland were fiercely independent. They fought back. The Romans never did feel comfortable here and their stay in the south of Scotland was a difficult one.

The Romans left in AD 105 and at about that time family groups lived in crannogs, which date from the fourth and fifth centuries. Crannogs were built for defence, usually in lochs or on marshy ground. They consisted of a large circle of strong wooden posts

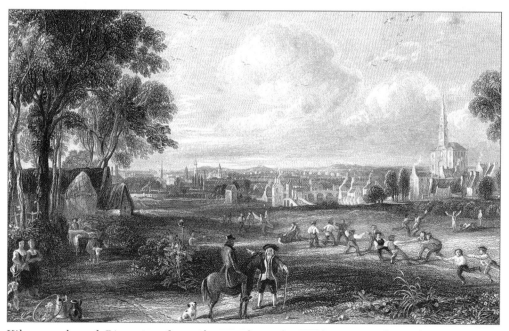

Kilmarnock and Riccarton from the south as depicted in an etching from the early nineteenth century. (*FBC*)

driven deep into the bed of the loch. The area within was then filled with earth and stones to create an artificial island on which dwellings were built. Crannogs often had a palisade. They were secure and access was often only available by a canoe, though some have been discovered with a causeway. The crannog at Buiston was investigated in the nineteenth century.

Long, long after the Romans had gone, the Christians were spreading their word across the country and travelling missionaries had to have somewhere to stop for the night; somewhere they could pray to their God. And so cells (pronounced with a hard 'k') or churches were built, often at crossroads. They were dedicated to Christian heroes, like Mhearnog. Legend links the name of the town with Mhearnog, or Marnock, an Irish saint, or missionary, who was the nephew of Saint Columba, the first man to bring Christianity to the country we now call Scotland.

Whatever the case, Kilmarnock remained a village for centuries. The biggest obstacle to development was that the town was inland and the River Irvine was not navigable this far from the coast. Kilmarnock folk got on with their daily lives, but gave their support to Wallace and Bruce when Scotland's troublesome neighbour tried to cast a greedy eye on its land. Much later, the good people of Kilmarnock supported the Covenanters when they stood up to a king from London who tried to impose himself as the head of the Church. They favoured the democracy movement

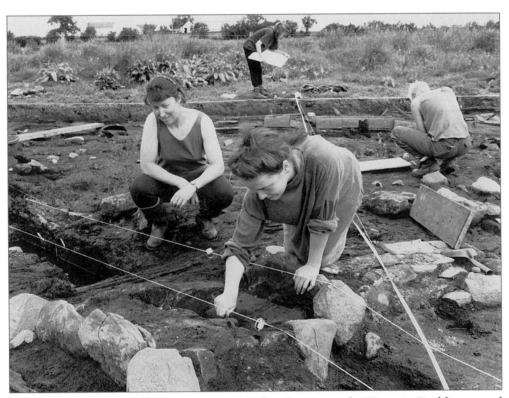

An archaeological dig at Buiston Crannog by the Scottish Historic Buildings and Monuments Department in 1990. (*S&UN*)

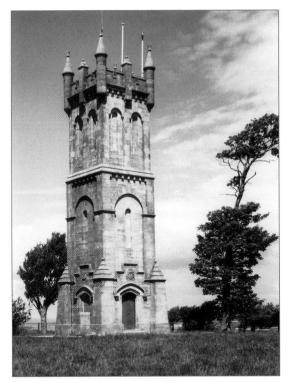

The Barnweil Monument, built to commemorate the heroism of Sir William Wallace, who helped to secure Scotland's independence from a troublesome neighbour. (*JH*)

at the end of the eighteenth century and the start of the nineteenth. Local folk backed the ban on slavery and supported women who wanted the vote, and they promoted the campaign to win back a Scottish Parliament. The residents of Kilmarnock are rebels.

Until the start of the nineteenth century, Kilmarnock lived by what was produced locally. But a revolution was starting – an industrial revolution, fuelled by coal, and Kilmarnock is built on coal. The Marquis of Titchfield inherited vast tracts of Ayrshire and was eager to exploit the rich coal reserves. The problem was how to get it to the coast for shipping to Ireland. Packhorses and horse and cart were not much of an option. The real possibilities were a railway or a canal. On the face of it the canal was the obvious choice. It was a proven technology, but in the end the railway idea won. Construction required an Act of Parliament, but the Marquis had a powerful ally. His father was the Prime Minister of the United Kingdom.

Construction began in 1808 and was completed in 1812. It was a remarkable railway – the first in Scotland; the first in the world to have a viaduct; the first to have a regularly scheduled passenger service; and the first in Scotland to try out a steam locomotive. In many ways that railway helped make Kilmarnock the town it is today. Engineering became crucial to the area – mine engineering, railway engineering and, to a lesser extent, marine engineering.

These engineers spread their wings and began to influence the town's other industries – carpet-making and shoe-making. Industrialists who came to Kilmarnock on business soon acquired a taste for another local product, a whisky made by Johnnie Walker, a name now known across the world.

By the middle and later part of the nineteenth century, the industries were being formed that would take the name of Kilmarnock to every continent. Thomas Kennedy invented an improved water meter and went on to establish Glenfield & Kennedy, at one time the biggest hydraulic engineering firm in the world, making everything from village pumps for most of the British Empire to laying much of the sewer system under New York.

Andrew Barclay started an engineering business that tackled any problem customers came up with. Later the firm was largely concerned with building locomotives and Hunslet-Barclay is still based in the town. Much of their work today relates to refurbishing locomotives. Carpet-making became important and so did the manufacture of shoes. The result was that BMK and Saxone were founded in Kilmarnock.

The town grew rapidly in the nineteenth century. The population soared, new streets were opened up, more churches and schools were built, more factories came and so did shops.

The twentieth century brought new power – electricity began to replace gas. A tram system was started. Old cottage industries emerged as world-beating major players. And like so many other towns, hundreds of Kilmarnock boys and men went off to war. Large numbers of them did not come back.

For all the changes, a visitor from 1840 who magically travelled in time to 1940 would have recognised much of Kilmarnock. But anyone who left Kilmarnock before about 1970 and returns today will be dismayed by the wholesale loss of character. All the old streets and neuks are gone. Most of the magnificent architecture of King Street, Duke Street, Portland Street and Waterloo Street is all gone, along with all the historic remnants of the old town – the bridges and plaques and the associations with Burns.

Kilmarnock continues to thrive and to swallow up farmland as it expands further. Just as the railway of 1812 gave a tremendous boost to the town, so too is the prospect of the new motorway to Glasgow. Construction is due to start in 2003, but new houses and new businesses have already been built because of it. Kilmarnock today remains a flourishing town.

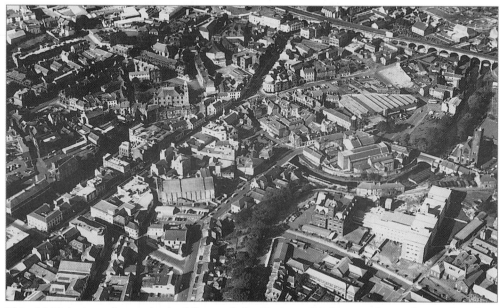

This 1960s' view shows the buildings of the Tech and Kilmarnock Academy, the Plaza Cinema, the Royal Bank rotunda and many of the streets and neuks that were destroyed in the 1970s. (*EAC*)

1

The Heart of the Town

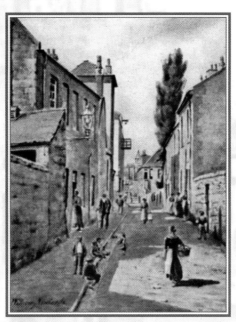

A nineteenth-century painting of Mill
Lane by William Newlands. This lane was
an old route that connected more
important streets, such as the ones that
later took the names of Old Mill Road and
New Mill Road. The Lane was originally
called Between the Dykes. (*EAC*)

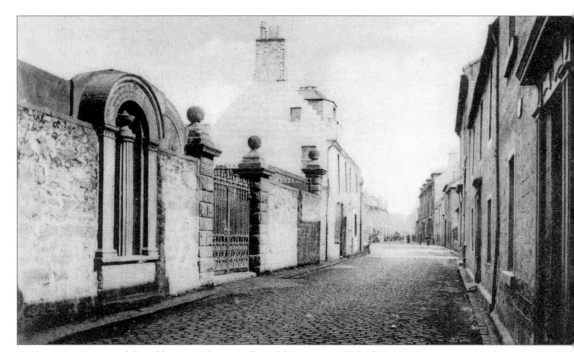

Soulis Street is one of the oldest in Kilmarnock and here you will find a monument to a Lord Soulis, but littl
is known of him. Legend says that in 1444 he led a party of English soldiers in an assault on Dean Castle b
that he lost his life in the attack. But this does not stand up to investigation – the date 1444 seem
inaccurate. Also, why would local people build a monument to a defeated invader? Towards the close of th
thirteenth century the de Soulis family was powerful and close to King Alexander III. In 1302 John de Sou
was promised safe passage by the English King Edward I to travel to France to negotiate a treaty, but Edwa
had lied and he had de Soulis detained because he was one of Scotland's Guardians. With him out of the wa
Edward I stepped up his campaign against Scotland. After the fall of Stirling Castle in 1304, the Sco
accepted terms that included the banishment of de Soulis for two years. During the crucial period
Scotland's determined fight to regain independence, John's brother William is said to have betrayed the cau

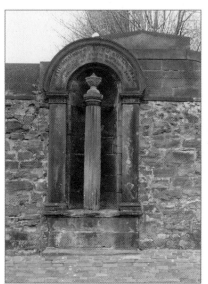

in his attempt to take over the monarchy – hardly a candidate for
monument anywhere in Scotland. Perhaps the original memori
commemorated the defeat of Soulis and in time became known
the Soulis Monument. (Above: *PC*; below, both photographs: *FB*)

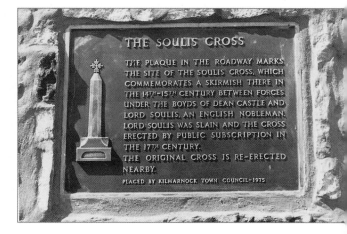

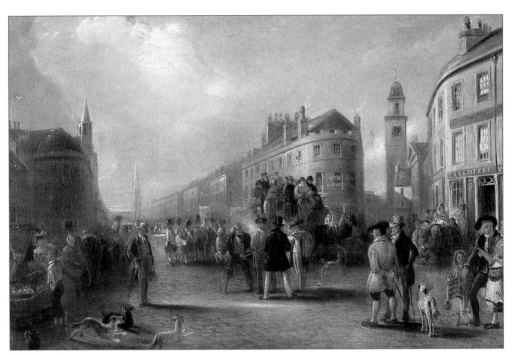

The Cross is still the hub of the commercial district of Kilmarnock, as it has been for more than 200 years. At the start of the twentieth century, the Cross was spacious and traffic free. No less than 7 streets converged there, with the lines of at least 2 of them being more than 450 years old. Before permanent shops, the market was held at the Cross, and it was also a place of execution, of entertainment and of royal proclamations. The painting above is by David Octavius Hill and shows the Cross and a view south down King Street as it was in 1840. The photograph below shows the Cross, looking north, in the late 1890s. (Above: *EAC*; below: *PC*)

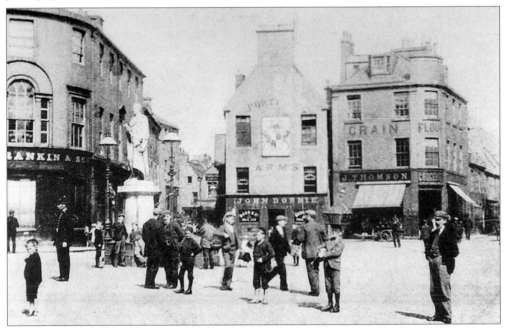

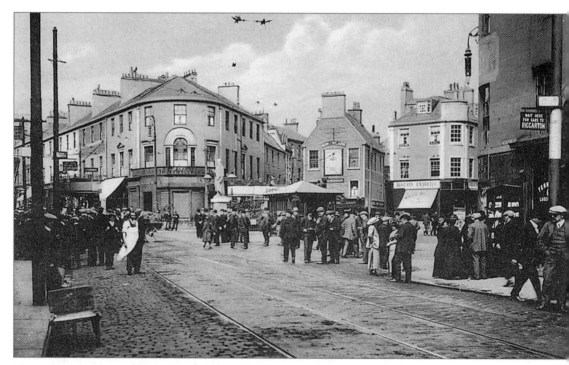

The Cross viewed from King Street, 1913. The kiosk to the centre right had just been erected to serve t needs of the tramways department, but it quickly became a source of irritation to just about everyone a was soon removed. The office was relocated in the building immediately behind the kiosk. In 1929 t statue to the left was deemed to be a traffic hazard and was moved to London Road. (*PC*)

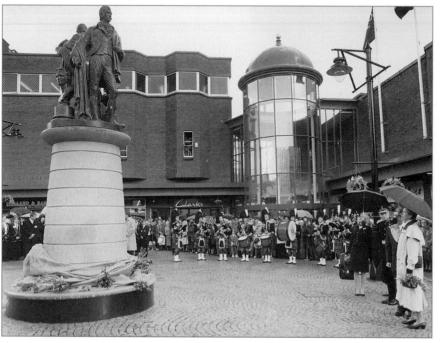

Princess Anne, havir unveiled a double statue of Robert Bur and his printer, John Wilson, 1995. Traffi had created too muc congestion and was but banished from th Cross in the 1970s, which left a spacious area for shoppers an a statue. Wilson tried to bring cheap classi to the masses and later, in 1803, he established Ayrshire' first newspaper, the *Ayr Advertiser*, which is still produced toda (*Burniston Studios*)

Cheapside Street, looking east towards the Cross, *c.* 1972. This street is one of the seven streets that converges on or radiates out from the Cross, and is also one of the oldest. Part of it still exists today, linking the Cross with Bank Street. The buildings seen here are typical late seventeenth century. Despite protests, these structures were demolished along with much of the central core of the town as part of the mid-1970s mania to modernise everything. The name Cheapside is thought to have originated from Chap-side. A chapman was a market trader, hence this name could translate into modern English as the site of the market place. (*FB*)

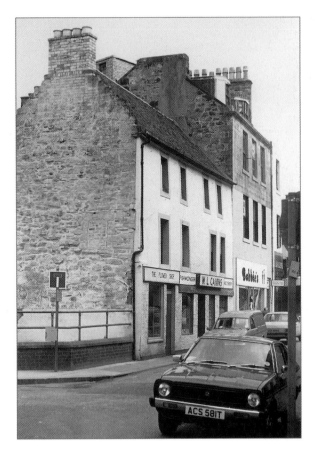

The castellated buildings seen here were photographed shortly before demolition in the 1970s and filled the space between Duke Street and Waterloo Street. Until the wholesale destruction of the 1970s, a great variety of worthy and interesting architecture existed in the streets facing on to the Cross and in the area around it. (*FB*)

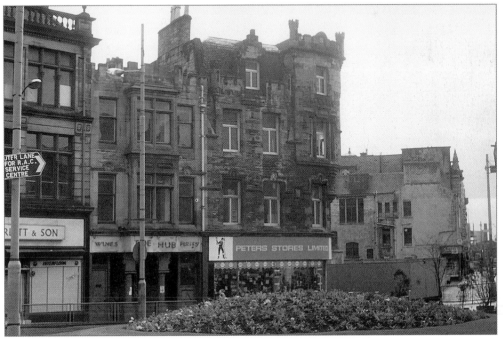

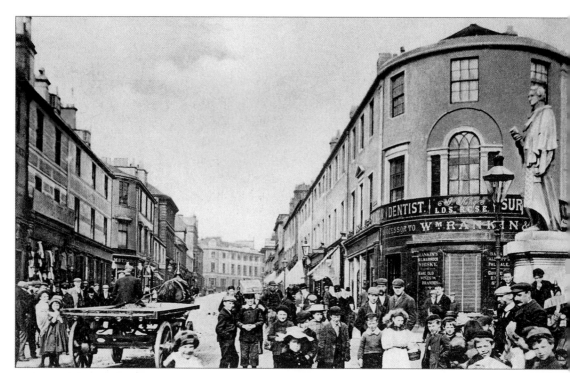

Portland Street was opened up in 1812 as an extension of King Street. It took traffic from the Cross on t
road to Glasgow. From the start it was a wide road with high buildings, and had several lanes and clo
leading off it. The photograph above dates from about 1900. Below is a photograph taken from almost t
same vantage point just a few years later. The biggest change is the use of tram cars, which made their fi
appearance in Kilmarnock in 1904. (*PC*)

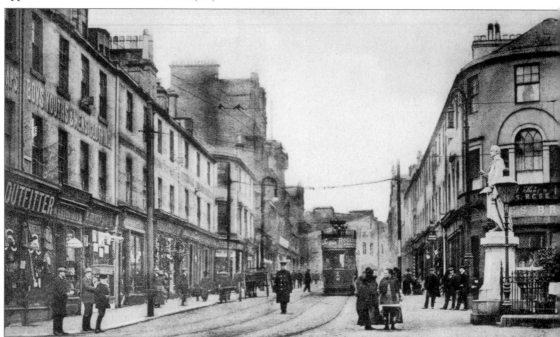

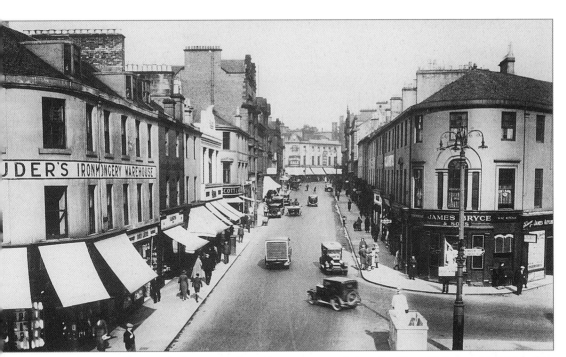

ams were in use in Kilmarnock for more than twenty years, being finally withdrawn in 1926. The
otograph above of Portland Street was taken in 1934, while the one below was taken in 1950. Apart
m the rotunda, built for the Royal Bank of Scotland, little changed in this period. In the 1980s
evelopment plans were drawn up for Portland Street and much of it was demolished. It is only in the last
r or two that it has started to be revitalised. (PC)

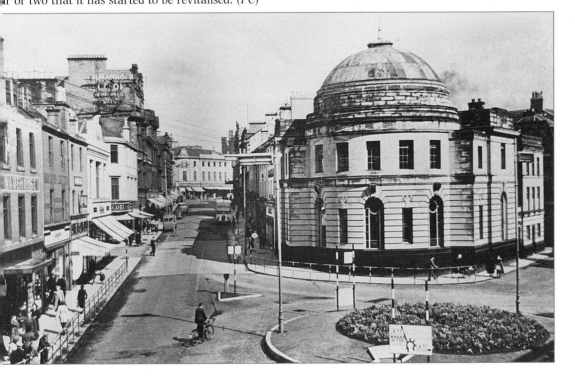

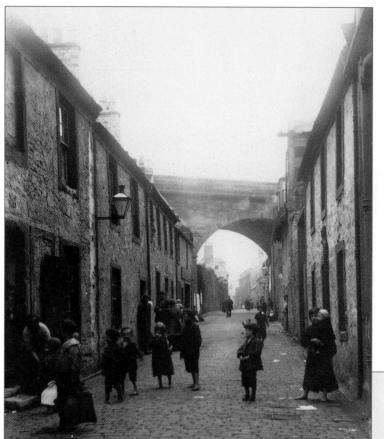

Fore Street, *c.* 1900. This ancie[n]t thoroughfare is thought to date from at least 1550. In the midd[le] of the eighteenth century the Foregait, or Fore Street, was the preferred location of merchants for their homes, but towards th[e] end of the nineteenth century i[t] had deteriorated to almost slum[] conditions. The street was demolished in the 1970s and replaced by a row of modern shops under the old name of Foregate, although the spelling was anglicised. (*EAC*)

Regent Street just before its demolition, *c.* 1973. Named after Regent Moray of Scotland, the street also has its roots in the seventeenth century. It may have first seen building in or soon after 1570, a year of political turmoil. Part of Regent Street was demolished in the 1850s to allow the construction of a wide new road leading from the Cross to London Road. This was Duke Street. Like Fore Street, Duke Street and Waterloo Street, Regent Street was wiped out by 1970s redevelopment. (*EAC*)

uke Street, called Victoria Street during its initial construction, was opened in 1859 and provided a wide
ew line from the Cross to London Road and the agricultural hall. Now the Palace Theatre and Grand Hall,
is was where all the important events in the town were held. Duke Street had some fine architecture as
n be seen in the photograph above, which was taken from the Cross in 1973, not long before demolition.
he photograph below was taken in about 1906 and is looking towards the Cross. (Above: *FB*; below: *PC*)

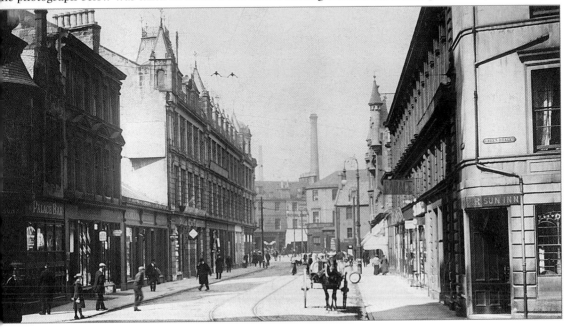

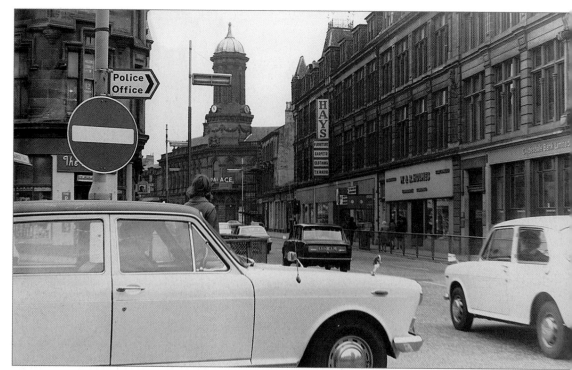

Duke Street, looking from the Cross out towards the Palace Theatre and Grand Hall building, *c.* 1973. (*RM*

The Burns Shopping Mall, the covered mall that replaced Duke Street, 1979. Originally named the Burn
Precinct, popular opinion determined the change of name. This shopping centre is linked to the town's bu
station. (*S&UN*)

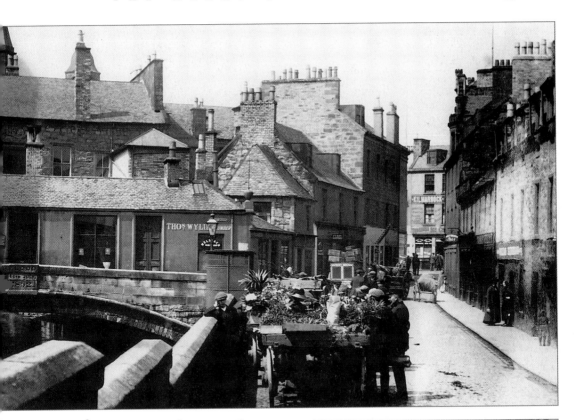

aterloo Street, *c.* 1900. It was nothing more than a
arrow lane until it was reshaped into a street in 1752,
 which time it was called Greenfoot. In 1815 it was
 named Waterloo Street in honour of the many local
en who took part in the Battle of Waterloo. It was here
at John Wilson took over an established printing
usiness and in 1786 printed the first edition of the
oems of Robert Burns. Despite the historic links with
urns, the street was demolished in the 1970s. (*EAC*)

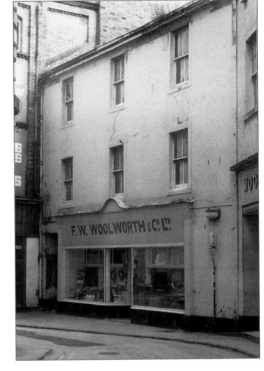

he rear entrance to Woolworths in Market Lane, 1972.
Vhen King Street was opened up, it cut across many
arrow twisting lanes. One of them was originally Water
ane, but it was later renamed Market Lane. Before King
treet was built, the building seen here was an inn
nown as Begbie's. It achieved lasting fame by being
amed in one of the poems by Burns. The inn, later the
ngel Hotel, was at one time one of the more important
stablishments in the town. However, with the
evelopment of King Street, Market Lane quickly lost its
tatus. (*FB*)

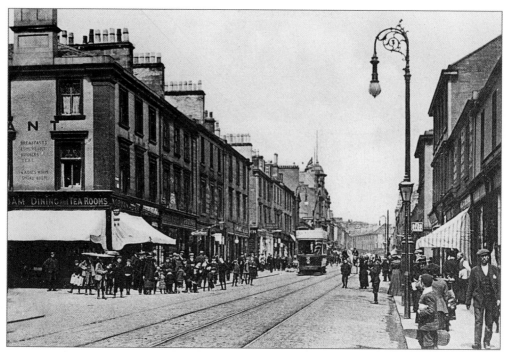

Of all the streets that radiated out from the Cross, for the last 200 years King Street has been the most important. It was opened up in 1804 and provided a long wide street from the Cross to the head of Titchfield Street. It immediately replaced the twisting narrow Sandbed as the main thoroughfare and soon attracted merchants and businesses eager to build impressive structures. The photograph above, looking north, was taken in the first decade of the twentieth century. The photograph below, also looking north, was taken in 1936. (*PC*)

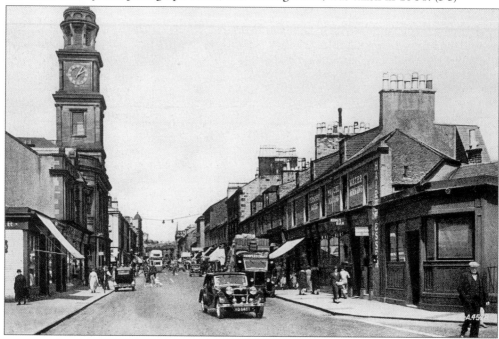

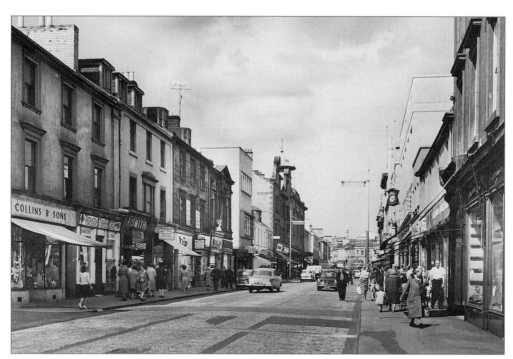

Both these photographs of King Street were taken in 1962. At the time, Kilmarnock was booming and there was full employment in the town's many industries. Most of the shops in the town centre were family run businesses and by the end of the 1960s, traffic had all but been banished from this part of the town to create a pedestrian shopping area. In the early 1970s the planners were let loose and, with the exception of the Graftons building, all the structures on the right of the photograph below were demolished and replaced by characterless, soulless brick boxes. (PC)

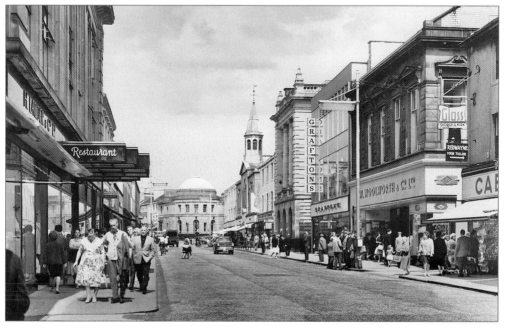

Bank Street, 1998. This road has somehow managed to retain some of its old-world charm, while streets all around have been wiped off the map. Going from the Cross, Bank Street is an extension of Cheapside. Originally Kirkhaugh, it was part of the burial ground of the Laigh Kirk. The ground sloped gently down to the river and had to be raised up before it could be built on in 1710. (FB)

The building seen here, at the corner of Bank Street and Bank Place, was demolished in about 1973 to make way for the Royal Bank of Scotland in adjacent John Finnie Street. Bank Street was quickly extended and as the eighteenth century turned into the nineteenth, the street was soon filled with various commercial enterprises and the buildings featured more elaborate architecture. (RM)

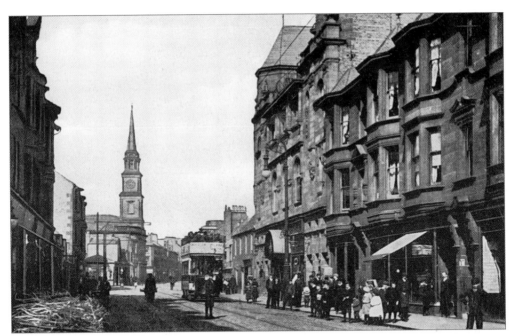

Titchfield Street looking towards the junction with King Street, 1905. The King's Theatre is seen in the centre of the photograph, and was opened in 1904. The route of what is now Titchfield Street was originally the road between Kilmarnock and Riccarton, and from the middle of the eighteenth century was often referred to as Titchfield Avenue. It was widened and straightened in 1865, when it became Titchfield Street. It provided a long, broad road from the Cross through Netherton and on to Riccarton, which was still regarded as a separate village at the time. (PC)

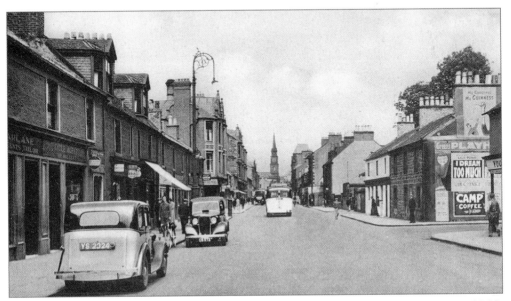

The other end of Titchfield Street, near the junction with High Glencairn Street, c. 1930. Despite the enormous changes in the town, a few of the buildings seen here remain today. (PC)

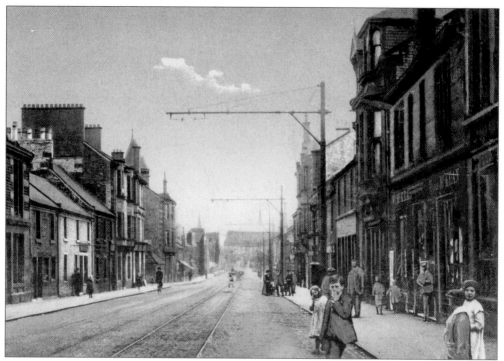

High Glencairn Street, close to the junction with Titchfield Street, in the first decade of the twentieth century. Many of the properties seen here are still recognisable today. (*PC*)

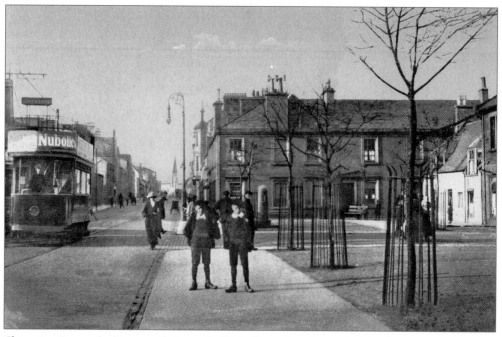

Glencairn Square looking north towards High Glencairn Street, 1906. The square, originally called Holm Square, was opened up in 1765. (*PC*)

Glencairn Square, 1959. The building on the left is the Dark Horse, later known as the Hunting Lodge, the Glencairn branch of the local Co-op Society. The buildings on the far right are those of Glenfield & Kennedy, whose hydraulic engineering works dominated Low Glencairn Street. Note the lack of traffic. Today this junction is characterised by traffic control and pedestrian-crossing lights. The distinctive style of the Hunting Lodge is the work of local architect, William Valentine, who also designed the Halfway House at Symington. (*PC*)

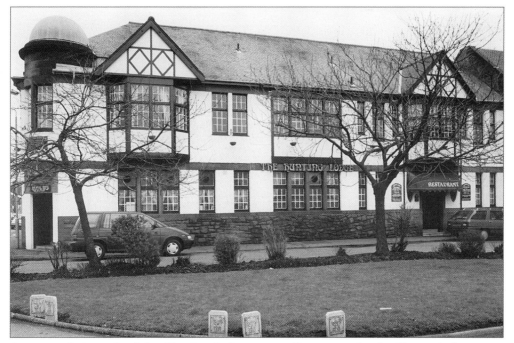

A recent photograph of the Hunting Lodge, an excellent example of mid-twentieth-century architecture that has tried to incorporate the Tudor style. It is now a popular pub that has won a string of national awards and stocks a fine range of real ales. (*S&UN*)

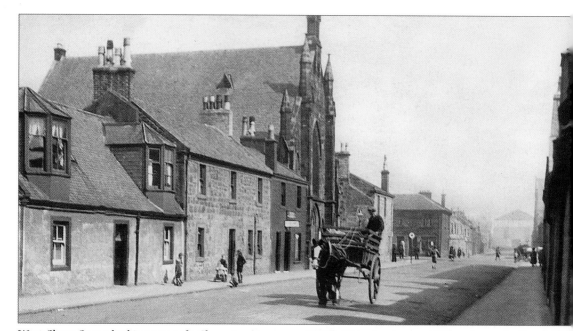

West Shaw Street looking towards Glencairn Square, *c.* 1900. This street runs off the square to the west a
is now dominated by a Safeway supermarket. Prominent on the left of this photograph is the Glenca
Church, now demolished. Most of the other buildings were houses, and some of the occupants ran sm
shops from their homes – a far cry from today's supermarkets. (*PC – Hugh Fulton Collection*)

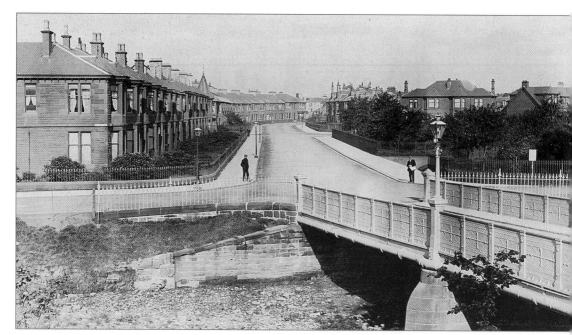

The bridge over Kilmarnock Water that links West Shaw Street and McLelland Drive, *c.* 1900. The brid
was built in 1888 by local railway engineers, Grant, Ritchie & Company. Three plaques on the bridge tell t
story of its construction, opening and subsequent rebuilding. (*PC*)

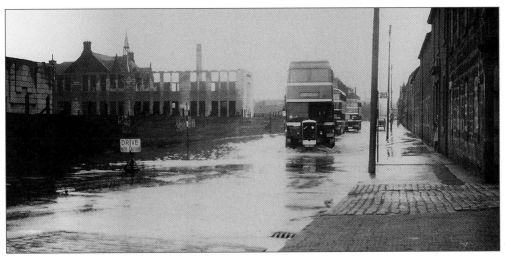

Low Glencairn Street, south of Glencairn Square on the route to Riccarton, photographed during the flood of 1951. This street has often been subject to flooding from the River Irvine, which takes a wide, sweeping curve round the street. It can therefore flood from East Shaw Street and the square or from Riccarton Bridge at the southern end. Despite the considerable amount of water on the road, the buses appear to be coping well. (*EAC*)

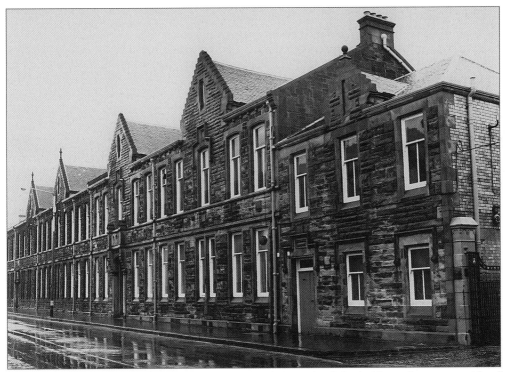

The works of Glenfield & Kennedy, which dominated much of the land on the eastern side of Low Glencairn Street, *c.* 1950. One of the town's biggest employers for several generations, the company reduced in size in the 1980s and these buildings were demolished and replaced by industrial units. (*EAC*)

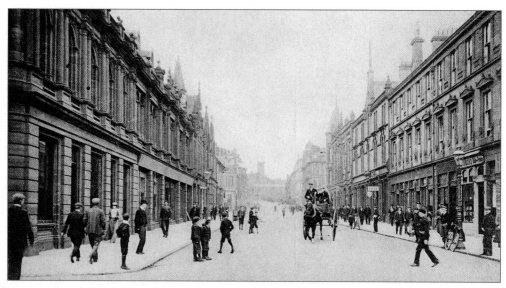

Despite the wholesale destruction of much of Kilmarnock's core in the 1970s, most of John Finnie Street remains intact. Unlike the piecemeal developments in other parts of Kilmarnock and in many other towns across the country, much of John Finnie Street was planned and today stands as one of the best examples of Victorian town organisation in the country. The line of the street, again, long, straight and wide, was opened up in 1864. Nearly all the buildings were constructed using local red sandstone and the street soon attracted many of the main traders and other commercial interests of the town. The photograph above was taken in the early years of the twentieth century and is looking north to the railway station. The photograph below was taken in 1939 from the railway station and is looking south to Howard Park. Although the traffic needs and the street furniture have changed, much of the original architecture remains today. (PC)

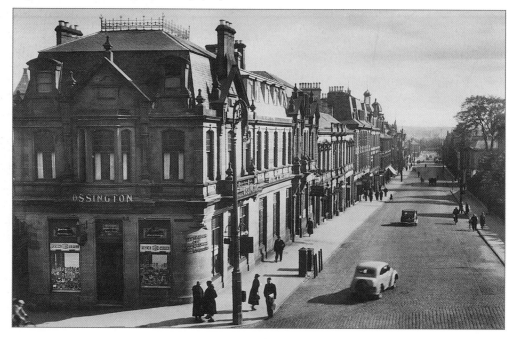

n Finnie Street, which
s from the top left of
 photograph to almost
way at the right, 1980s.
 group of buildings to the
tom right include the
t office and sorting office
l the triangular building
the left is the former
narnock Standard
ting works. The streets
rsecting with John
nie Street are Grange
ce and Bank Place.
C)

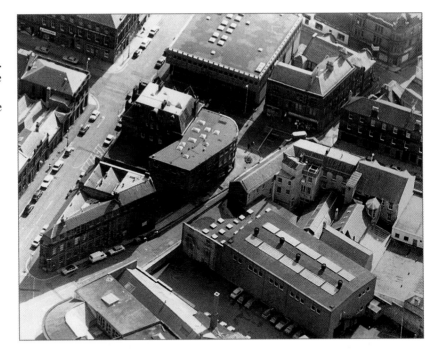

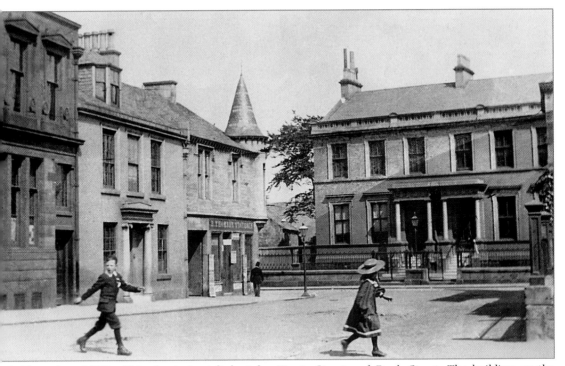

nk Place, late 1890s. This short street links John Finnie Street and Bank Street. The building on the
rner with the turret was used by Thomson & Robertson, stationer's and tobacconist's, and is now the
ices of the *Kilmarnock Standard*. The building facing the photographer became the Bank of Scotland,
hough this branch was due to close early in 2003. (*EAC*)

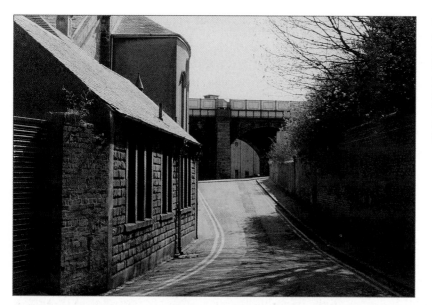

Garden Street, one of the
earliest roads in the town
2003. Its original name w
Back o' the Yards, but as
yards gave way to garden
the name was changed.
Today only a small part o
remains and it is a narro
back street. (*FB*)

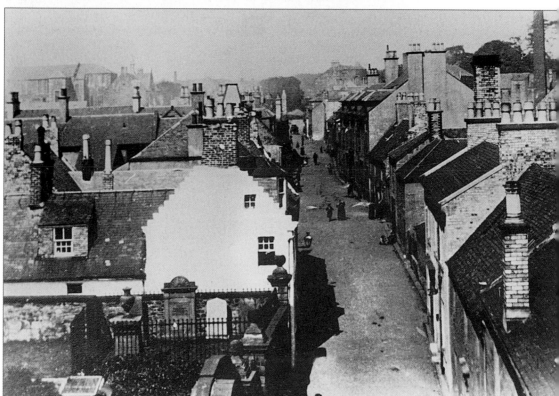

High Street, part of the earliest thoroughfare out of the town on the road to Glasgow, 1890s. A section
this street existed in much the same form from the 1600s to the 1900s. The meal market was built here
1705 and was still thriving when it was rebuilt in 1840. In the middle of the eighteenth century Hi
Street was where merchants chose to make their homes, but by the middle of the nineteenth century it w
narrow and poorly lit. (*PC*)

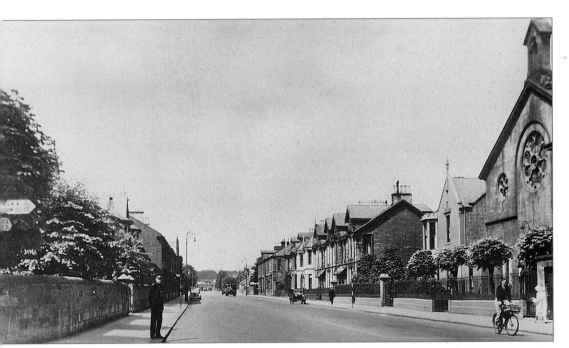

rtland Road, another of the more important streets in the town, *c.* 1950. When it was built it extended to
western extremity of the town beyond St Marnock Street and the town centre, although today it is
garded as a town-centre street running from John Finnie Street towards Irvine Road. When it was
nstructed, most of the buildings became homes to the better-off, but today many of the properties are used
commercial businesses. (*PC*)

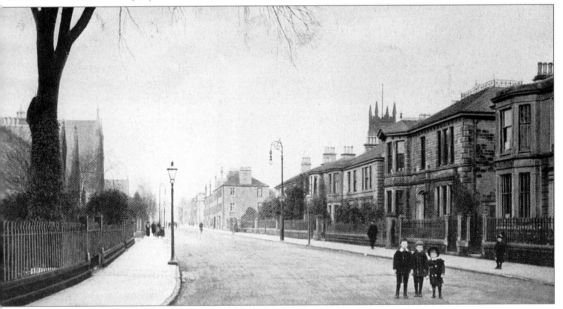

ndonald Road looking towards John Finnie Street, 1905. If instead of turning off John Finnie Street you
straight on, you come into Dundonald Road. Originally Dundonald Road was called Bullet Road. House-
ilding began here in 1828 and has been going on ever since. Today Dundonald Road is the longest street
Kilmarnock, stretching out to the edge of town. (*PC*)

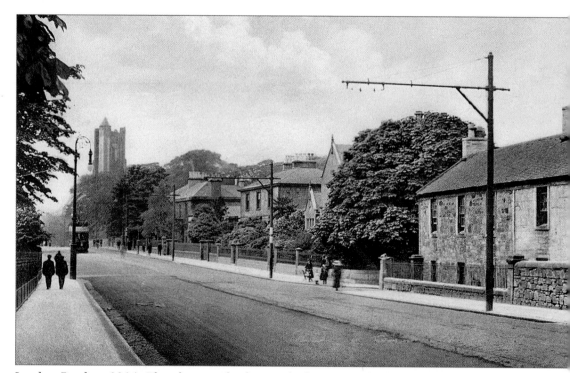

London Road, *c.* 1914. The photograph above is looking towards the town centre and the Henders
Church, while the photograph below is looking in the opposite direction towards Hurlford. London Road h
long been the approach to the town from the east. The bridge over the river next to Henderson Church w
built in 1827. The street has many fine villas, mostly dating from Victorian times. *(PC)*

2

Here & There

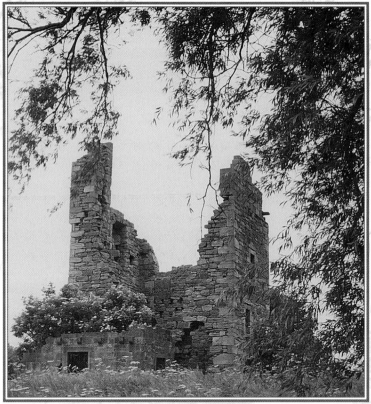

Remains of a pumphouse at Caprington. Throughout the Kilmarnock
area there is evidence of the past, some of which is obvious and some
is not. It ranges from ancient tumuli to industrial remains.
Kilmarnock was built on coal and the earliest pits in the area were
sunk by the Friars of Fail in the fourteenth century. It was not until
the start of the nineteenth century that coal was extracted on
anything like an industrial scale. In order to keep the pits free of
water, huge pumps were used. Coal extraction in the Kilmarnock
area went on until the middle of the twentieth century. (FB)

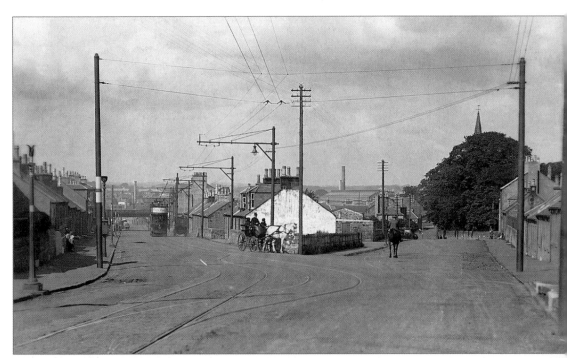

Riccarton was a separate village and parish until Kilmarnock absorbed it. Kilmarnock had been made burgh of barony in 1591, Riccarton in 1638. These two photographs of Riccarton have been taken fro almost the same spot – looking towards the junction of Campbell Street and Campbell Place – above in 19 and below in 1998. The road layout can still be identified, but almost everything else has changed. (Abo PC; below: FB)

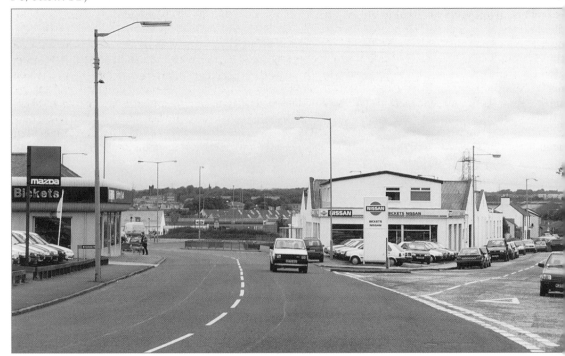

s building once stood in Fleming Street, Riccarton, close to the site of Riccarton Castle, home of the
llace family and probably birthplace of Scotland's greatest hero, Sir William Wallace (1270–1305). The
icture was demolished in the early 1980s. A plaque, barely visible here, explains the historic significance
he site and is now incorporated into a wall in front of the Campbell Street fire station. At a time when
glish King Edward I had invaded Scotland with the intention of subjugating the people, it was Sir William
llace more than anyone else who rallied the people into an efficient resistance movement and set the
ne for the wars of independence. Wallace's birthplace is also claimed by Elderslie in Renfrewshire, where
 Wallace family held land, but the Wallaces' main base since 1165 was at Ellerslie, Riccarton. Wallace is
 of the most significant heroes in Scottish history and it is incredible that nothing significant has been
ne in his native Ayrshire to honour the man who helped mould Scotland into a nation. (FB)

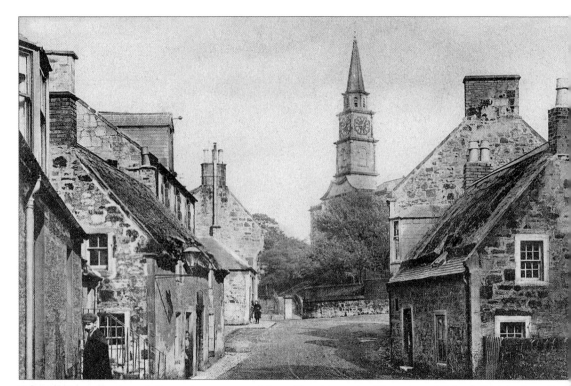

Even in the early twentieth century some of the old cottages in Riccarton still had thatched roofs. T
photograph above is of Old Street, *c*. 1904, while the one below is of New Street, early twentieth cent
The contrast in building styles is quite evident. New Street was originally called Crompton Street but a
significant changes there in the middle of the nineteenth century, the name was changed to New Street.
the time this photograph was taken street lighting was still provided by gas and there were no mo
vehicles on the roads. (*PC*)

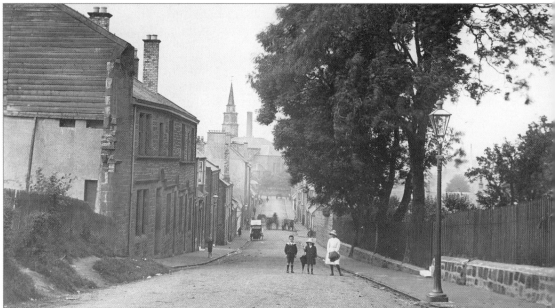

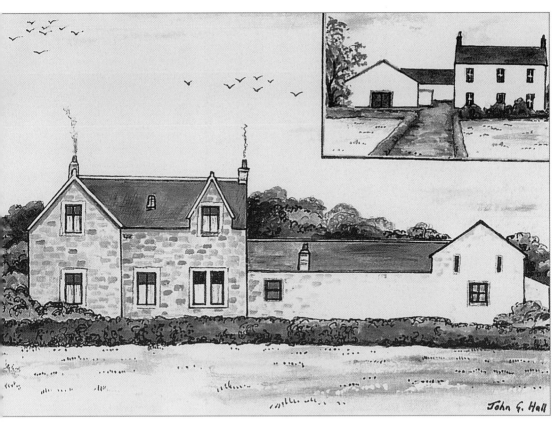

th Dean Farm and, inset, New Farm, *c.* 1967. Kilmarnock grew as a fairly compact town, surrounded by ne agricultural land. As the demands for land grew, more and more of the farms close to the town were llowed up, mostly for housing. These included the two farms seen here, both of which were demolished and area used to build the massive New Farm Loch housing scheme in the late 1960s and early 1970s. (*JH*)

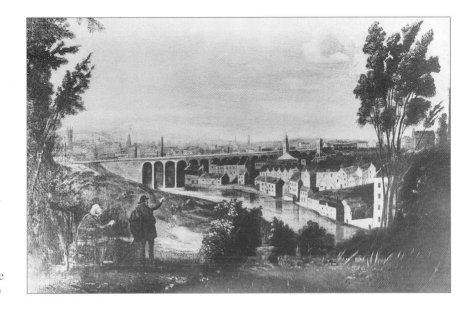

e railway viaduct, nted by James nock. This picture bably dates from t before the railway duct was built in 48, for it is not irely accurate. wever, other ldings seen are true resentations. (*EAC*)

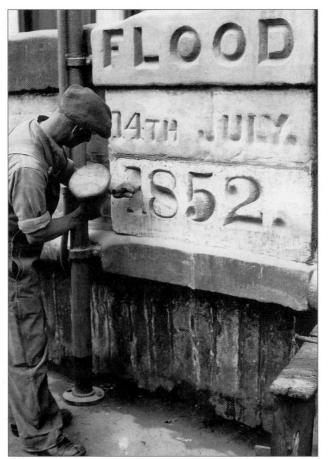

Kilmarnock has often suffered from flooding and although the effects are usually limited, three inundations stand out as being particularly devastating – 1852, 1932 and 1994. The flood of 1852 caused so much damage that a memorial stone was erected on the flesh market bridge. In the above photograph it is being repaired by traditional methods in time for its centenary in 1952. This flood was unusual in that it had not been raining in Kilmarnock, but further upstream. Increased land drainage, restricting the river in the town, and choking of the river by weeds, rubbish and silt all played a part in the severity of the disaster. Although much property was damaged and many bridges, houses and shops were actually destroyed, the town was relieved that there was only one fatality. (*WS*)

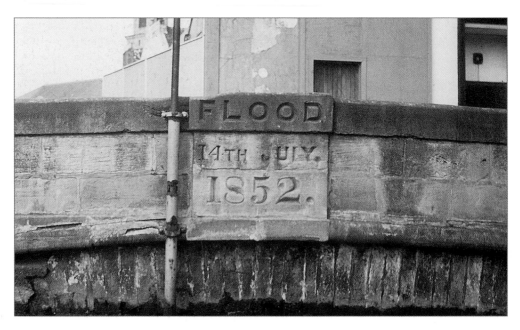

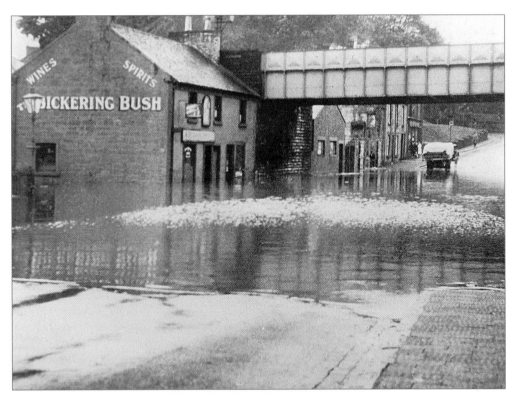

Kilmarnock has often suffered from flooding. The two most serious floods of the twentieth century were in January 1932 and December 1994. Both floods were caused by the overflowing of the River Irvine. The top photograph shows flooding at Riccarton in 1932 and the one below is of Brewery Road and Lawson Street in 1994. After more flooding in 1995 flood walls were built on the banks of both the River Irvine and the Kilmarnock Water. (Above: *JMcG*; below: *FB*)

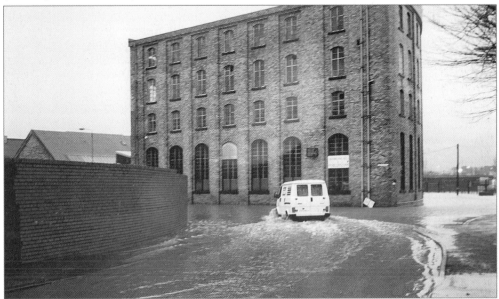

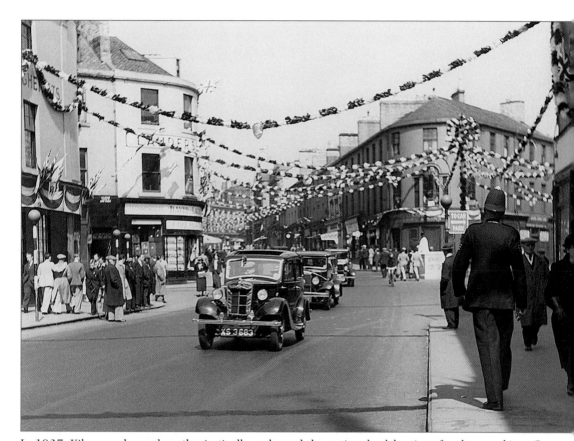

In 1937, Kilmarnock people enthusiastically embraced the national celebrations for the new king, George
The coronation events seemed like a relief after the troubled times of the Depression. The year before h
seen Edward VIII become king but then abdicate over his determination to marry the woman of his choi
It wasn't quite a constitutional crisis, but feelings in the country did run high. Although the econor
situation had improved, there were rumours of deeper problems in Europe. All things considered, a ro
coronation seemed like a national party and no one wanted to miss it. As seen in the photograph above, t
town's streets and shops were all well decorated for the occasion and various events were held including
parade of just about every organisation anyone could think of. The photograph below on the left show
parade of Girl Guides in King Street. The photograph on the right shows the Boys' Brigade marching dov
the same street. (*JB*)

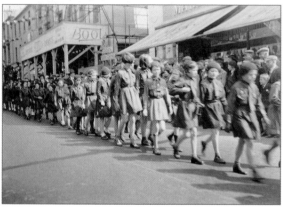
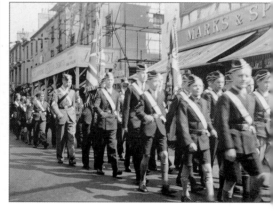

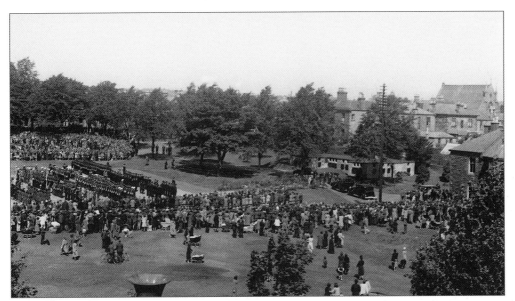

Crowds gathered in Howard Park for the visit of King George VI to inspect the civil defence arrangements, 1942. He and Queen Elizabeth were introduced to many people in various branches of civil defence as well as those in civilian life. The first person they met at Howard Park was Julia Chantry. She worked with ARP control but had a sprained ankle and was put in the VIP tent so she did not have to stand for a long time. (*EAC*)

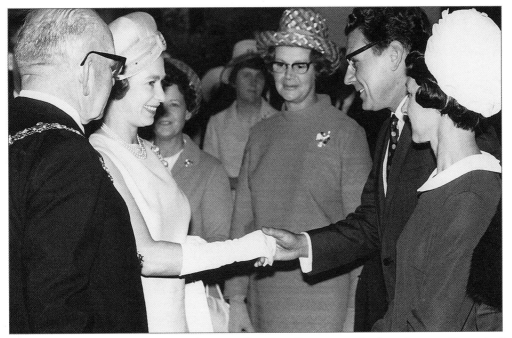

Queen Elizabeth shaking hands with Councillor Tom Ferguson, who later became Provost of Kilmarnock, 1970. On this occasion the queen visited Kilmarnock and met various civic leaders and industrialists for lunch. (*TF*)

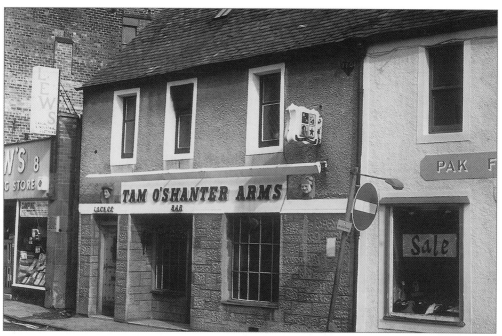

Pubs are part of community life and Kilmarnock has seen a great variety of them. The photograph above is of the old and popular Tam o' Shanter Arms, built close to the site of John Wilson's printing works, where the poetry of Robert Burns was first printed. 'Tam o' Shanter' remains one of Burns' greatest poems. The building was constructed in 1761, probably as a private house. In those days the street was called Greenfoot, though it was later changed to Waterloo Street and was swept away with so much else in the 1970s. The pub seen in the photograph below is the Howard Arms in Glencairn Square, one of several establishments in the town that have a long history and over the years have occupied more than one site. (*FB*)

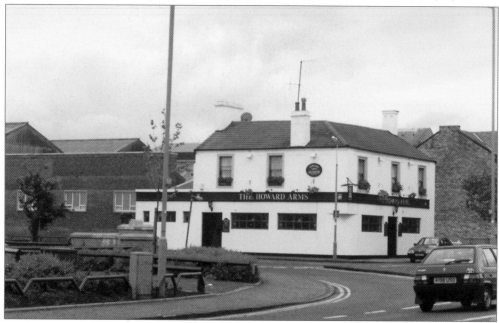

3

Commerce & Industry

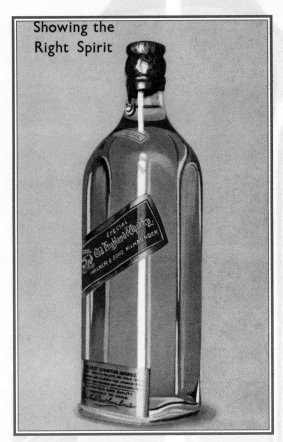

A bottle of Johnnie Walker whisky. This is a
familiar product in every country of the world
where alcohol is a legal product. The square
bottle with the slanted label became something of
a twentieth-century icon and contains what
might be called the true spirit of Kilmarnock. (*PC*)

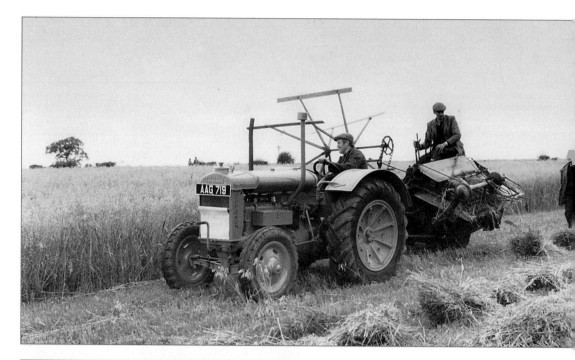

A 1940 Fordson tractor linked to a 1950 McCormick binder to cut and harvest oats during demonstration of this process. The oldest industry is agriculture and the rich fertile soil of the Irvine Valley has been exploited for many generations. Until fairly recent times towns like Kilmarnock depended largely on locally grown produce and until the second half of the twentieth century farming was not highly mechanised. In this photograph we see the start of that process. (*JC*)

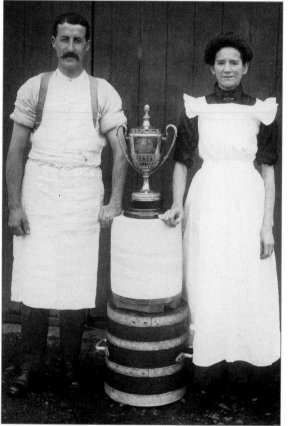

Unidentified winners of the Kilmarnock Agricultural Cup, which was presented for cheese-making, in the early twentieth century. Ayrshire is famed for its dairy cattle and associated produce. Locally produced cheese was exported in the days before mass production and mass markets. At the end of the nineteenth and the start of the twentieth centuries Kilmarnock held some of the most important annual cheese fairs in the county. (*PC*)

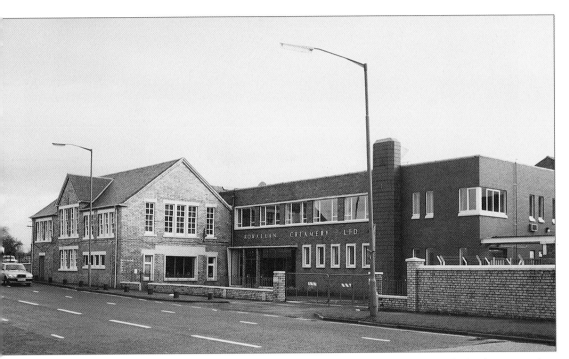

...e of the most important dairy businesses was the Rowallan Creamery, seen here in the early twenty-first ...ntury. It was established to the north of the town in 1888 by a John Wallace and made a product that at ...e time was called butterine, now widely recognised as margarine. Among the better-known brands ...oduced at Kilmarnock was Banquet Margarine. In 1961, Rowallan Creamery became part of Associated ...itish Foods. At the start of the twenty-first century, house-building had encroached to such an extent that ...e creamery was no longer in a rural setting and the plant's owners closed the factory in early 2003. (FB)

...he mushroom farm at Struthers, 1990s. In sharp contrast to the old agricultural products and services, ...is newcomer to Kilmarnock is based on the edge of the town. It supplies the general public and ...permarkets. (FB)

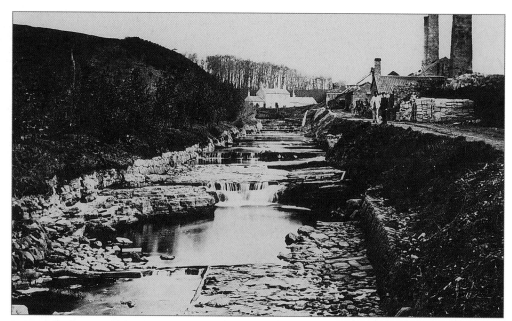

Living off what could be taken from the land was the way of life for centuries, and among the businesses that grew and flourished from stone quarrying was J. & M. Craig. The business had its roots at the Dean Quarry early in the nineteenth century, but went on to manufacture bricks and all manner of sanitary products and potteryware for building – pipes, chimneys and decorations. They found a ready export market, too, and the business was soon booming. In 1884 they started a new pottery in Kilmarnock at Longpark. In 1919 this was transferred to Shanks, but the business could not survive the economic upheavals of the late twentieth century and the site was cleared for housing. The photograph above is of Dean Quarry, late nineteenth century. The photograph below shows a stone lion from J. & M. Craig, c. 1997. (Above: *EAC*; below: *FB*)

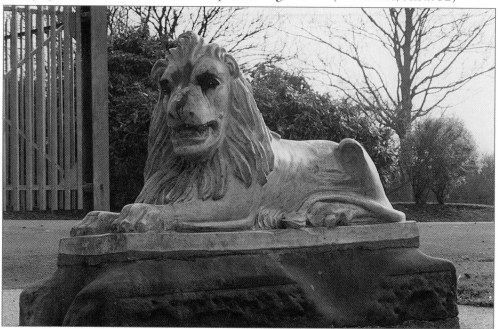

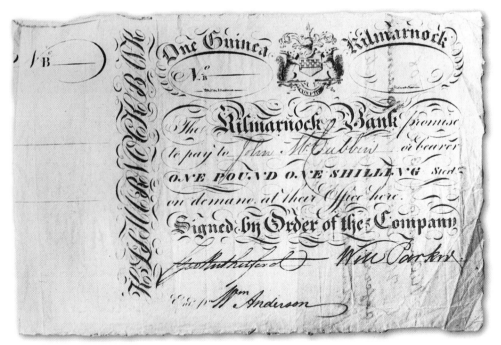

A one guinea note issued by the Kilmarnock Bank between 1802 and 1821. The banks have played an important role in the development of most towns and cities and the Kilmarnock Bank was established in 1802, and lasted until 1821. Scottish banks pioneered the introduction of paper money and the Kilmarnock Bank was no exception. Their notes were for one and two guineas. These were more like today's cheques and each was personally signed by the manager. (*BoS*)

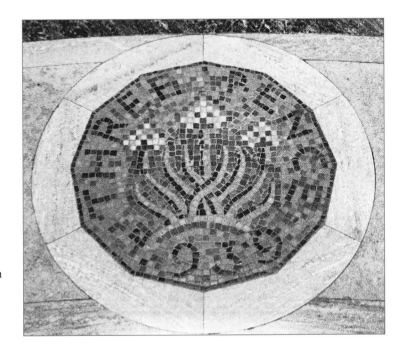

he mosaic of a *3d* coin featured side the branch of the Royal Bank ened at the Cross in 1939. When w banks were opened, they were ten the most imposing buildings in e area, both inside and out. In 939, *3d* was enough to post ree letters, but today it is equiva-nt to little more than 1p. (*S&UN*)

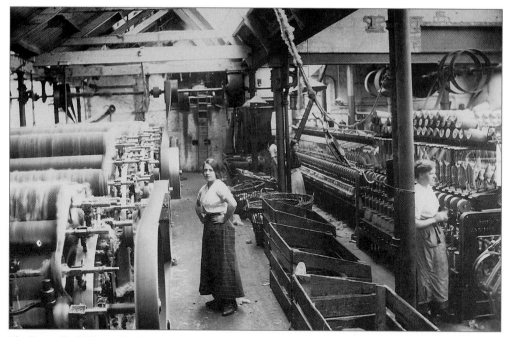

Blackwood's Mill, *c.* 1917. Kilmarnock has a long association with woollen products such as bonnets, blankets and stockings. The Blackwood family were making bonnets as early as 1625. In 1728 a Maria Gardiner brought a group of carpet-makers to Kilmarnock, thus establishing a business that would become important for the town. In 1847 the Blackwoods began making 100 per cent wool and wool-blend yarn for carpet-makers. (*EAC*)

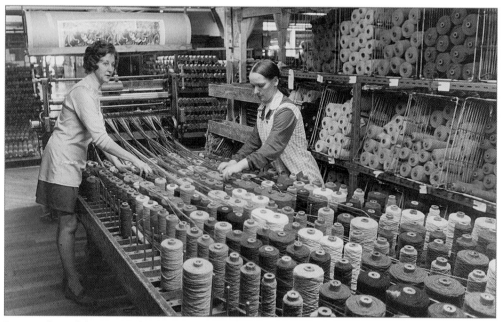

Prepared wool being used in carpet-making in the BMK plant in Kilmarnock, 1970s. The company earned a reputation for high-quality carpets and exported their products all over the world. Many top hotels and cruise liners had BMK carpets. (*S&UN*)

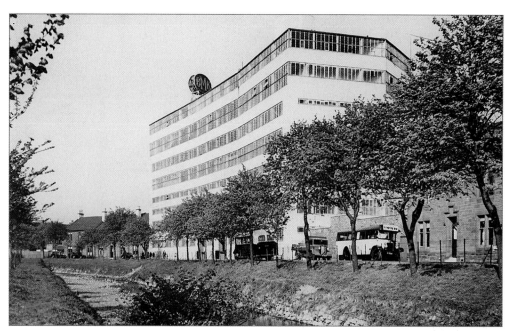

The BMK factory, 1938. It was a John Wilson who set up the first carpet-making factory at Burnside, using a handloom. In 1879 he sold his business to James and Robert Blackwood. This partnership split in 1882, when James moved to Townholm and later Western Road to specialise in producing the woollen yarn for carpet-makers. Robert stayed at Burnside and in 1908 formed a partnership with Gavin Morton, founding a new business, Blackwood, Morton & Sons, better known everywhere as BMK. (*PC*)

The BMK factory in Glencairn Square, 1980s. The immediate post-war boom called for rapid expansion and BMK found a site in the square, on the corner of Low Glencairn Street and West Shaw Street. The site was developed for BMK in the early 1950s and the company remained there until the 1980s. Today a supermarket is based there. (*S&UN*)

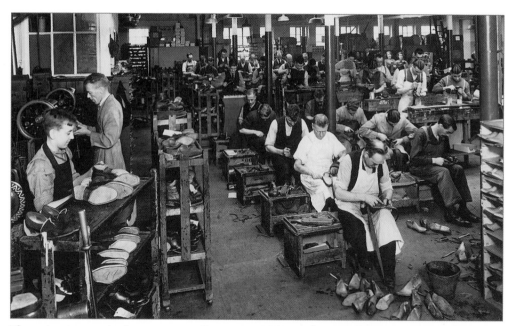

The extensive repair department at Saxone, *c.* 1950. Making and repairing shoes and boots was well established as a cottage industry and grew rapidly as the nineteenth century advanced. In 1837 the value of footwear made in Kilmarnock amounted to £50,000 per annum. There were many makers, but the one key manufacturer to emerge was George Clark. In 1908 Clark's merged with the business founded in England by Frank and George Abbot. This became known as Saxone and was based in Kilmarnock. (*CM*)

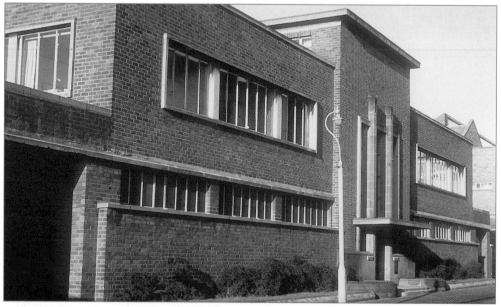

The Gleneagles factory, built to accommodate the manufacture of Hush Puppies in the 1940s. The second half of the twentieth century saw a shift in the type of shoes being made and the building seen here was photographed shortly before it was demolished in 2002 to make way for a supermarket. (*FB*)

British Made Saxones

Saxone shoes testify to the high standard of British Craftsmanship and the generous measure of British value.

Saxone shoes for men, in all styles and leathers, cost from 25/9-, and are made in a large range of fittings.

SAXONE SHOES

89 Titchfield Street, Kilmarnock

Stores Everywhere.

An advertisement for Saxone shoes, 1950s. As with any brand leader, Saxone relied heavily on advertising to promote brand awareness. In the 1950s the points that had to be emphasised were that the shoes were British-made and that there were 'stores everywhere'. Note also that this advert is aimed at men; other adverts were aimed at fashion-conscious women. (*Author's Collection*)

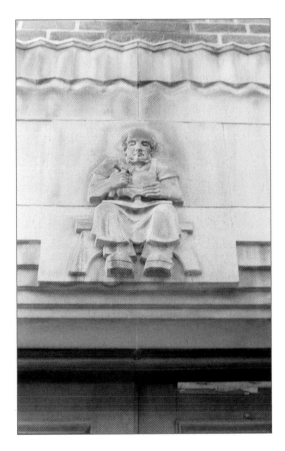

he cordwainer at work – this detail of a shoemaker as mounted on the front of the Saxone factory in Titchfield Street. When the building was demolished to make way for a sports centre, the stone was reserved and put on display in the new building. (*FB*)

Andrew Barclay quickly established his skills in his father's works and in 1840 founded his own engineering business, largely to provide machines for textile manufacturers. His skills as an engineer were always in demand and he was soon constructing all sorts of machinery for coal mining and the railways. It was as a locomotive builder that Barclay was to make his name. The firm produced all manner of specialised industrial locomotives, not only building them, but repairing them as well. Barclay-made locomotives soon found a niche market and were exported to many countries. The photograph above is of 0–4–0 saddle tank No. 1964, working at Trafford Park, Manchester, in 1929. The photograph below is of a group of women engineers at Barclay's, probably taken during the First World War. (Above: *PC*; below: *Author's Collection*)

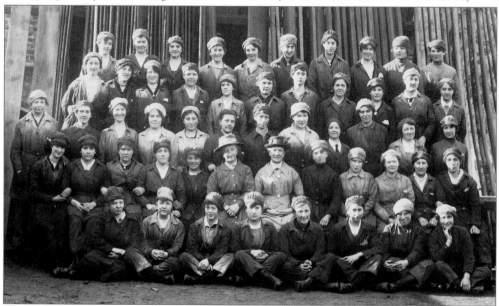

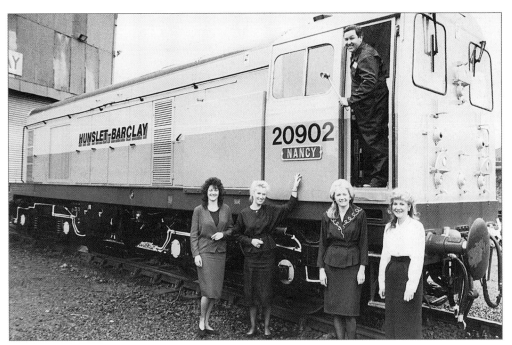

In 1989 Barclay's, now trading under the name of Hunslet-Barclay, refurbished seven Class 20 British Rail locomotives at Kilmarnock. The new job of these engines was to work as weed-killing trains on the British Rail network. They operated in pairs during spring and summer, with a spare one being kept at Kilmarnock. After being refurbished the locomotives were named after the members of the office staff – No. 20902 was named after Nancy Law, seen here second from the left. (*S&UN*)

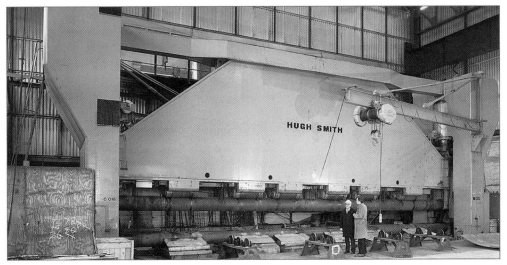

A Hugh Smith 600-tonne combined shipyard roll and flanging press at Barclay's, 1985. A similar piece of equipment to the one seen here was made in Kilmarnock in 1985 for export to India. Hugh Smith & Co. of Glasgow developed and produced many machines and from the 1960s some work was sub-contracted to Andrew Barclay, Sons & Co. in Kilmarnock. In 1983 the Glasgow company was acquired by Barclay's who transferred the work to Kilmarnock. (*S&UN*)

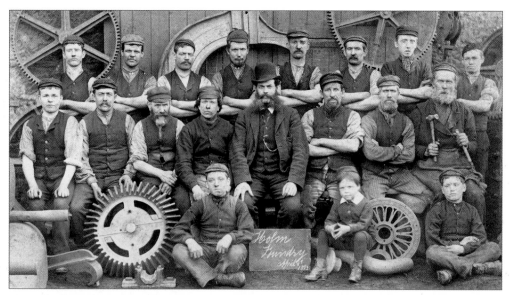

Some of the men and boys who worked at the Holm Foundry, 1893. Engineering was established in Kilmarnock at the start of the Industrial Revolution and various foundries were set up throughout the nineteenth century. The Holm Foundry was established in Titchfield Street in 1840 by Rodgers and Blair. The same area had several other engineering workshops. (*Author's Collection*)

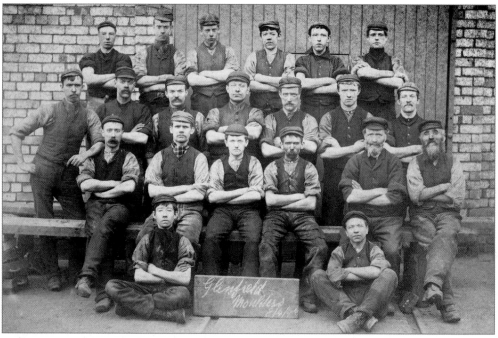

Moulders at Glenfield Foundry, 1890s. Of all the foundries in the Kilmarnock area, none was more important than that of the Glenfield Iron Company. It was established by Thomas Kennedy to serve the needs of his other company, the Kennedy Patent Water Meter Company. In 1899 the two companies were merged to form Glenfield & Kennedy Ltd. (*Author's Collection*)

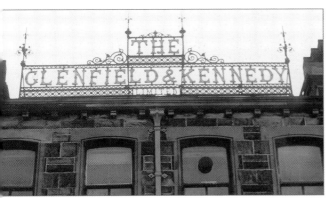

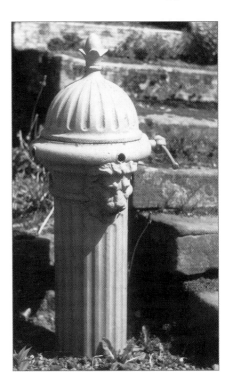

s said that the business of Glenfield & Kennedy had its origins
en Thomas Kennedy took a party on a Sunday school trip
d came across a fountain with a faulty valve. Water was being
sted so Kennedy, a gunsmith by trade, pondered on the
oblem and started working on the design for an improved
ter meter. His design was patented in 1852 and the company
w from then. The photograph above is of the ornate
meplate proclaiming 'The Glenfield & Kennedy Limited' on the
mpany's premises. The photograph on the right is of a typical
nfield water pump, once common not only in Scotland but in
st about every corner of the British Empire. (FB)

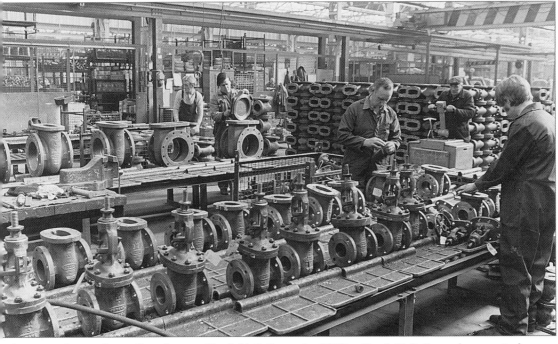

orkmen producing butterfly valves at Glenfield & Kennedy, 1970s. Glenfield & Kennedy grew to become
e biggest hydraulic engineering firm in the British Empire. It installed floodgates in the London
derground, allowing stations to be used as bomb shelters. (S&UN)

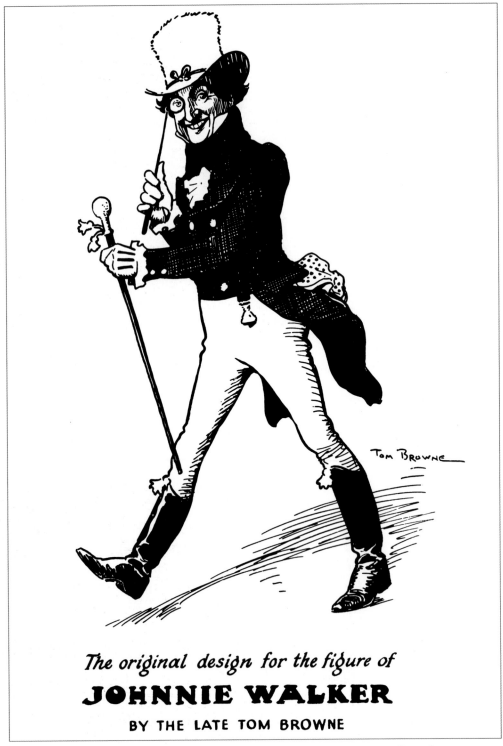

The original design for the figure of

JOHNNIE WALKER

BY THE LATE TOM BROWNE

The 1908 drawing by Tom Browne that has featured in many Johnnie Walker advertisements.
In various forms, the striding man is still used today. *(JW)*

he bond, opened in 1897 in Strand Street, soon became too small for the Johnnie Walker business. ilmarnock's most famous product is the range of whiskies produced by Johnnie Walker. He was born in 805 and by 1820 was running his own grocery shop. He was content with that, but his son and grandson ere not. Both called Alexander, they in turn helped transform a small local business into one of the world's rst global brands, using a mixture of maverick marketing and aggressive advertising. (*FB*)

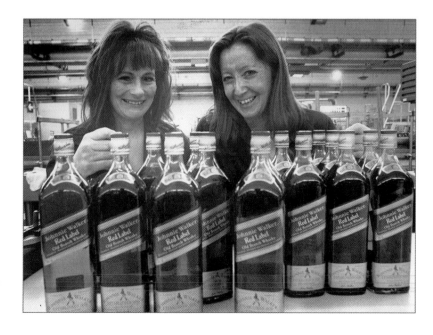

Vhisky galore! Walker's ilmarnock plant bottles 0 million cases of whisky a ear – that's ,080,000,000 bottles, and 0 per cent of that is xported to every country in 1e world where alcohol has ot been banned. (*S&UN*)

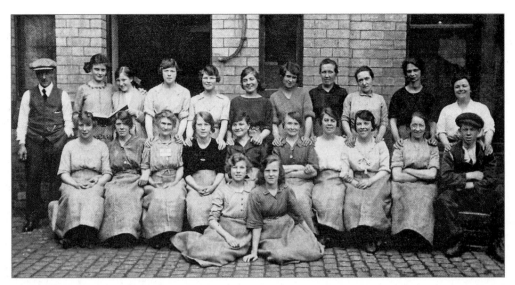

Workers at Gilmour & Smith, 1918. Not all of Kilmarnock's commercial enterprises found fame across the world, but many did build up a national reputation. One such business was Gilmour & Smith which had a jam and jelly factory in Low Glencairn Street in the first half of the twentieth century. (*Author's Collection*)

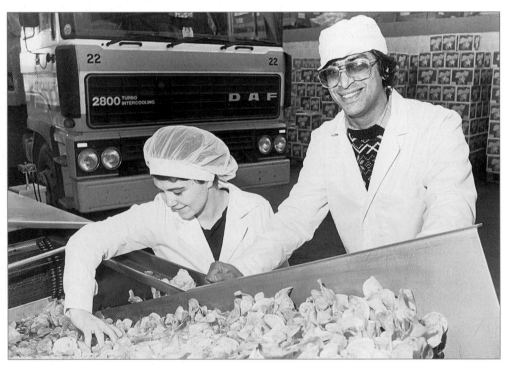

The Starlight Crisp factory, 1980s. Another local enterprise, which, unfortunately, did not last long, was that of potato-crisp-making. Starlight Crisps was set up, enjoyed a brief period of success, but simply could not compete against the big national companies. (*S&UN*)

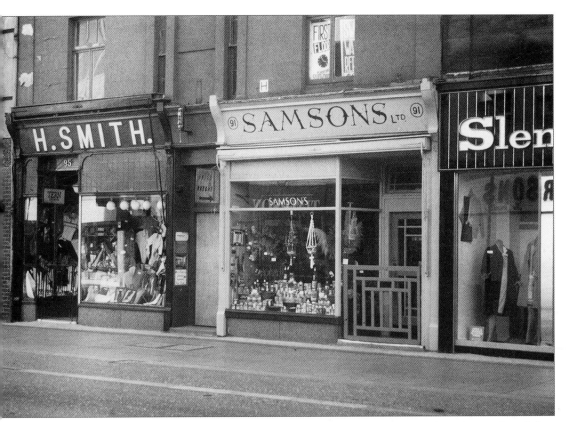

...mson's shop, early 1980s. Many small local businesses lasted for generations. Samson's was founded in ...'59 by Tam Samson. This was the year that Robert Burns was born and Tam Samson and Burns became ...eat friends. The business changed greatly over the years, being a seed supply business for farmers, later a ...rsery and latterly a florist's. The shop closed in 1984. (*FB*)

...label for the popular drink Iron Brew, ...1984. This drink was produced by ...rner & Ewing, another company ...th a long history. The business was ...nded in 1810. Until the 1960s they ...ttled beers under licence. Then their ...ain business became the production ...lemonades of various flavours. In its ...er years some products were ...arketed under the name of Turner's. ...e firm had a wide customer base and ...the days before canned drinks, it was ...dely known. However, it could not ...mpete against the centralised power ...big international companies and ...osed in 1984. (*Author's Collection*)

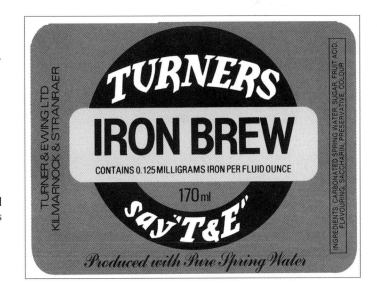

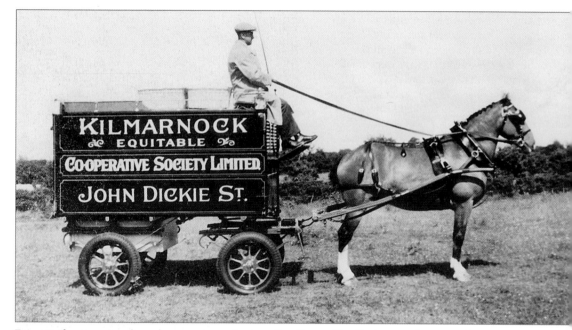

Few retail enterprises have been as important as the Co-op. The first ever attempt to form a co-op came
1769, when the weavers of Fenwick formed a self-help co-op. Their principles were later followed by th
better known co-op in Rochdale. Inspired by the ideas of co-operation the Kilmarnock Equitable Co-operati
Society was founded in 1860, when their first 'shop' opened two nights per week. Innovation w
paramount and the business rapidly expanded. They were soon able to use delivery vehicles like the one se
in the photograph above, taken in 1905, and there were branches across town and in neighbouring village
There were bakeries and other services to back up the chain of shops and special interest groups were set t
to fulfil a social need. The photograph below is of the Glencairn Square branch and was taken in abo
1906. (Above: *Author's Collection*; below: *PC*)

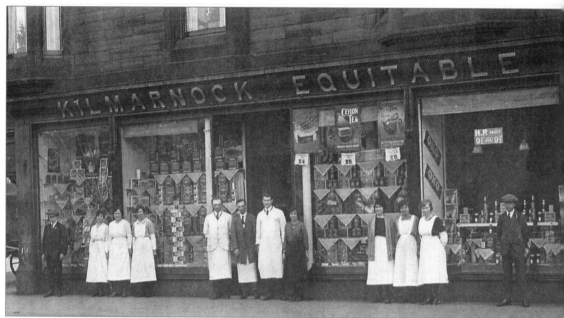

...rgaret McGougan and her daughter Daisy ...tside their newsagency and stationery shop, ...09. There was a time when nearly all the ...ops in towns such as Kilmarnock were small ...d family owned. McGougan's was typical of ...s type of corner shop and was located at the ...rner of Low Glencairn Street and James Little ...eet. (*PC*)

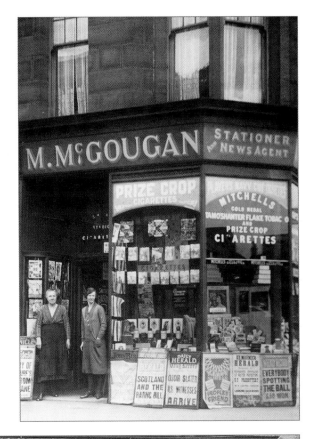

...bert Campbell's grocery shop in Dean Lane, ...hich had previously been run by William ...thbertson, 1914. Many of the local shops built ... a good reputation with their customers and ...en the owner sold the business, it was ...stomary for the new owner to link his name ...th his predecessor. Note the state of the displays ...oints of unwrapped meat! (*PC*)

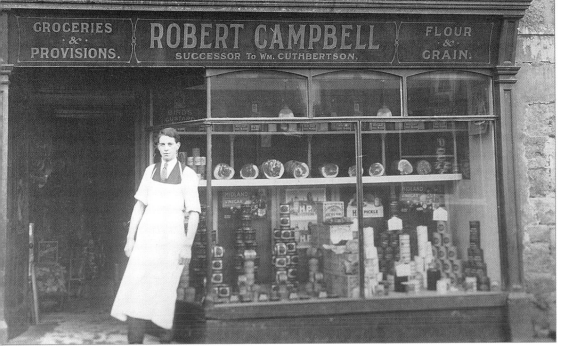

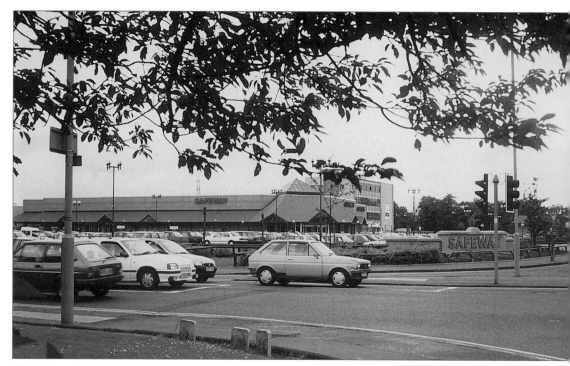

The shape of shopping today – the Safeway supermarket in Glencairn Square. Gone are the corner sho
with the staff who knew every customer. Today we have vast supermarkets taking the place of tradition
shopping centres. Many like this Safeway store come with huge car parks, their own petrol station and
variety of goods unimaginable a generation ago. (FB)

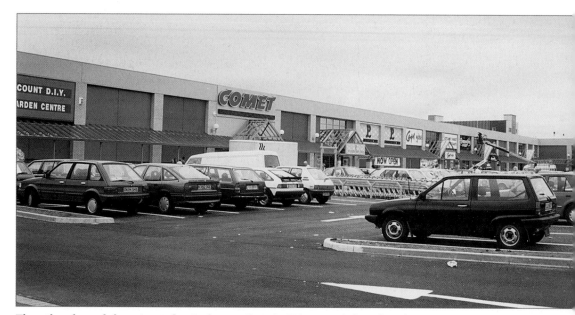

The other face of shopping today is the retail park. Kilmarnock has the Glencairn Retail Park, where a fe
national names operate out of new warehouse-style buildings which have no history and no character. (FB

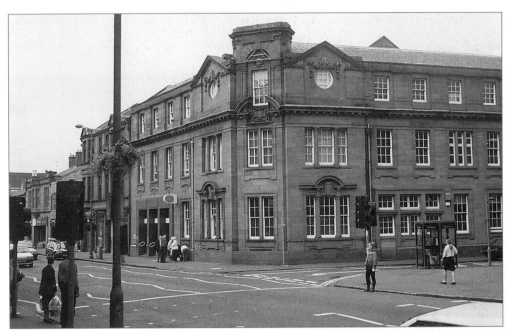

The post office in John Finnie Street, 2003. Kilmarnock was one of the first post towns in Scotland, not because it was a place of importance, but in 1662 it was a convenient stop on the route from Edinburgh to Portpatrick and on to Ireland. There has been a post office in the town ever since that time. (*FB*)

The Beansburn sub-post office, *c.* 1960. As postal business increased, particularly towards the end of the nineteenth century, a network of town sub-offices was opened. The Beansburn sub-office was opened on 1 April 1909 and lasted until 31 May 1985, although its location changed during that period. (*EAC*)

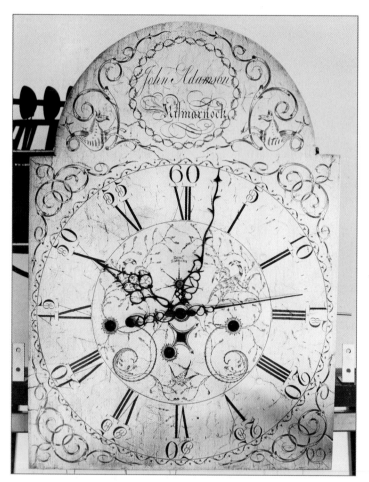

An early nineteenth-century clock-face by John Adamson. Kilmarnock has seen a great many commercial concerns come and go and a surprisingly large number of these have been in the fields of instrument and clock-making. (*Author's Collection*)

Jimmy Hood beside his American Steam Laundry Lorry, 1930. As the twentieth century progressed, the variety of local businesses grew. One of these was the American Steam Laundry, which used its own vehicles. Jimmy was a soldier during the First World War and was captured, spending some time as a prisoner of war. (*HM*)

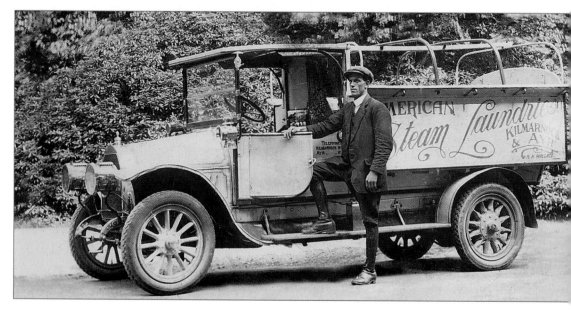

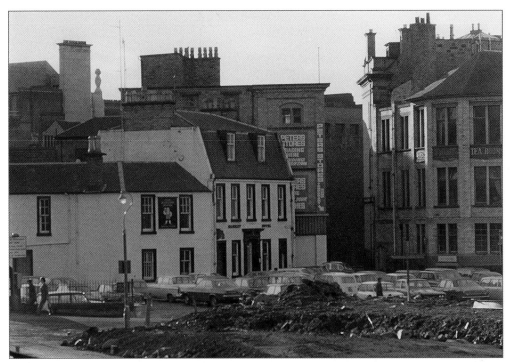

The demolition site of the Market Hotel, 1970s. As travel became more common more inns were opened. One of the oldest of these was the Market Inn, later the Market Hotel. (*RM*)

To date the newest hotel in Kilmarnock is the Park Hotel, which opened in 2002 within the grounds of Kilmarnock Football Club at Rugby Park. (*S&UN*)

The *Kilmarnock Standard* printing works where the *Standard* was printed for more than seventy years. important part of any community is a good, honest newspaper. The *Kilmarnock Standard* was founded 1863 and quickly gained a reputation for providing reliable and fair news of all local events. In those da the paper also featured national and international news. Today the building is used by a variety businesses, including a popular pub. (*FB*)

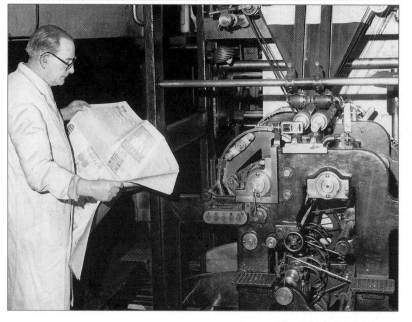

Hot off the press – a copy of the *Kilmarnock Standard* is checked in 1963, the paper centenary year. Things have moved on since then. Today the paper is tabloid and regularly gives readers abou 128 pages of news, features colour pictures and, of cour advertisements. (*EAC*)

4

Kilmarnock at Play

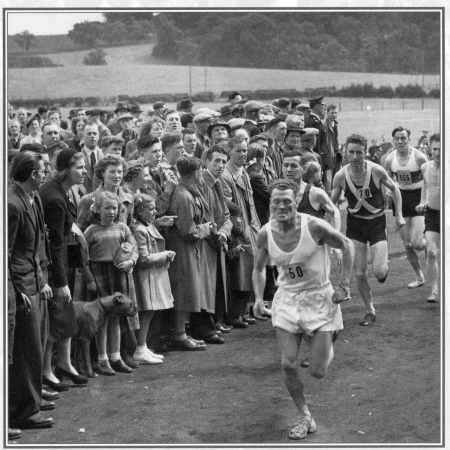

A family sports day for the employees of Saxone and their families, Struthers Park, *c.* 1950. Several of the main employers in the Kilmarnock area had their own sports facilities in the town. The man in the foreground is marathon runner Harry Howard. Harry later worked for Massey-Ferguson in Kilmarnock and eventually went to Australia where he spent the rest of his life. (*CM*)

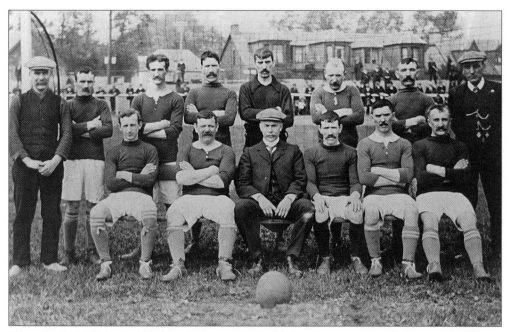

Kilmarnock Athletic Ancients' football team, *c*. 1914. In the nineteenth century working men hardly had time for anything. Towards the end of the century, however, working conditions began to change and many men soon found themselves with Saturday afternoons off work. The result was a big increase in recreational clubs. (*PC*)

Crowds outside the Saxone Pavilion at Struthers Park enjoying a summer sports day, 1950s. The site of the pavilion is now occupied by houses. (*CM*)

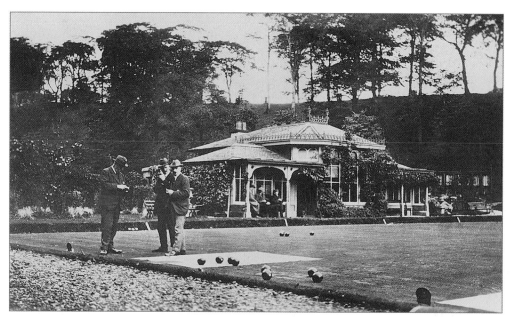

Kilmarnock bowling green and clubhouse, 1932. Bowling was enjoyed in ancient times and the Kilmarnock Bowling Club was founded in 1740 and is the oldest continuous bowling club in Scotland. Former Kilmarnock club member William W. Mitchell was foremost in laying down the standard rules of the game. (*PC*)

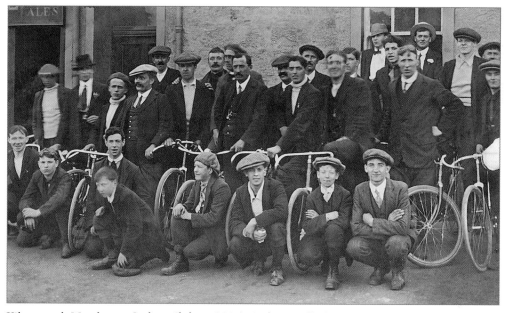

Kilmarnock Merchants Cycling Club, *c.* 1905. Cycling really began with Kirkpatrick McMillan, who is credited with the invention of the modern bicycle. His first major journey was from Thornhill in Dumfriesshire to Glasgow, a journey that took him through Kilmarnock, where he was seen by Thomas McCall. It was McCall who first started manufacturing bicycles and the popularity of the pastime resulted in the establishment of various cycling clubs. (*PC*)

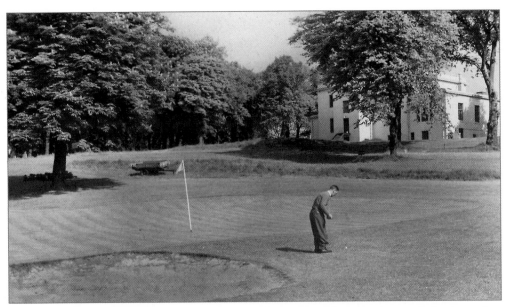

Annanhill golf course, Kilmarnock, 1959. Golf is a Scottish invention and the town has two municipal courses. The first, Caprington, was opened in 1909. In 1929 Annanhill House and estate was purchased by the town using profits from the supply of electricity. Plans were made for a golf course, but it did not open until 1957. (PC)

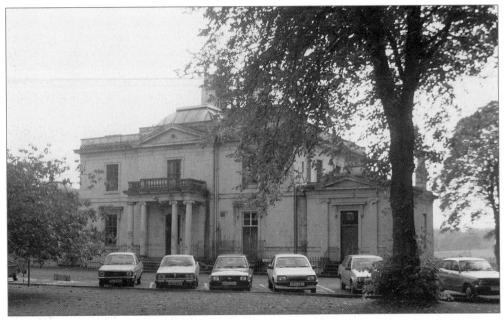

Annanhill House, which dates from 1796. After the purchase of the house by the town in 1929, plans for a proposed golf course were postponed until 1957. In 1950 it was leased to Massey-Harris, later Massey-Ferguson, for use as their workers' social club. When the golf course was finally opened the house became the clubhouse. More recently, a new clubhouse has been built and the mansion has been refurbished and split into flats. (FB)

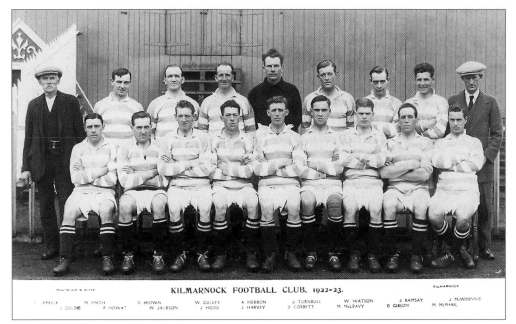

KILMARNOCK FOOTBALL CLUB, 1922-23.

CARRICK M SMITH D BROWN W CULLEY A HERRON J TURNBULL W WATSON J RAMSAY J McWHINNIE
 J GOLDIE R HOWAT W JACKSON J HOOD J HARVEY D CORBETT M McLEAVY D GIBSON M McPHAIL

Kilmarnock has one of the oldest football clubs in Scotland, though when the club was an informal one in 1868, members played football and rugby, the divide between the two games being much less than it is now. An echo of that time is that Kilmarnock FC still plays at Rugby Park. The rules of the game in those days were about as informal as the club. Gradually the game grew in popularity, rules were tightened, football and rugby went their separate ways and national and international games were played. The photograph above shows the team of 1922/3. Kilmarnock's successes were many, but those talked of as legendary were the match against Hearts in 1965, which resulted in Kilmarnock winning the League Cup, and the match against Einthracht in 1964. On this occasion Killie were 3–0 down in the first leg and 1–0 down after just 90 seconds in the second leg. But Killie won that match by 5–1, or 5–4 on aggregate, and made front-page news in Scotland and Germany. (*S&UN*)

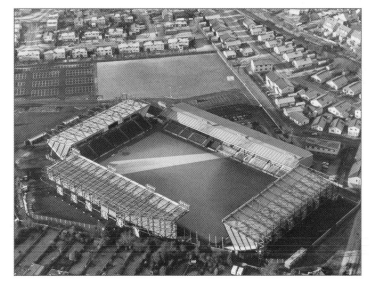

The new Rugby Park in 2003, revamped and rebuilt as an all-seater ground in the wake of the crowd disaster at Hillsborough. (*PC*)

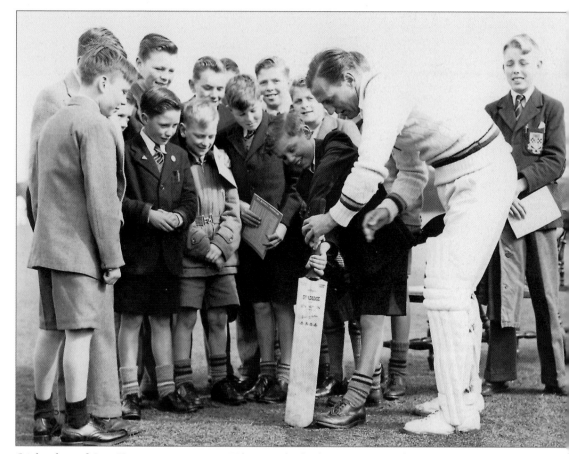

Cricket legend Len Hutton, on a visit to Kilmarnock, freely gives some advice to young enthusiasts, 19[?] Cricket has never been as strong in Scotland as it is in England, but some Scottish clubs have been m[?] prominent than others. Kilmarnock was one of these and the Kilmarnock Winton Cricket Club was form[?] in 1852. (*S&UN*)

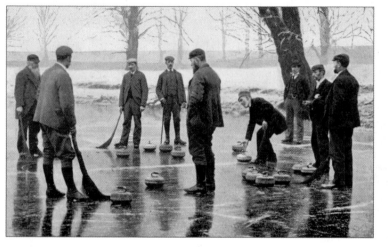

A game of curling, 1908. Curling or the 'roarin' game', goes back hundreds of years and although [?] roots were probably Dutch, the modern game is a Scottish invention. In 1740, there was a particularly severe winter and the streets round the Cross were dammed and flooded for the bene[?] of curlers, who enjoyed their spor[?] for twenty-three successive days, not including Sundays, of course. Local curling received a great boo[?] in 2002 when the Scottish team won a gold medal at the Winter Olympic Games. (*PC*)

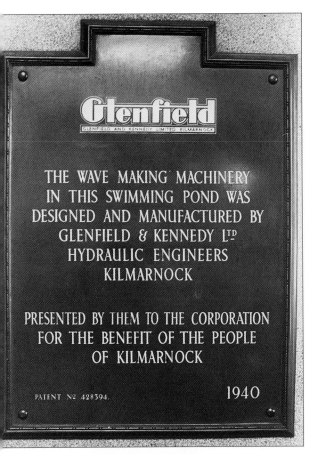

Until the start of the twentieth century, when a swimming pool was built at Kilmarnock Academy, all swimming was in open water, such as pools in local rivers. The town's municipal swimming pool was opened in 1940 and contained a unique feature, a wave-making machine, designed and built locally by Glenfield & Kennedy and given to the people of the town. For more than twenty years Kilmarnock was the only indoor swimming pool in Britain with such a facility. During the Second World War, the pool was used for commando training. (S&UN)

An early ladies' day meeting of the Kilmarnock Swimming Club. The club was formed in 1902 when the only indoor facility available was attached to Kilmarnock Academy. (DM)

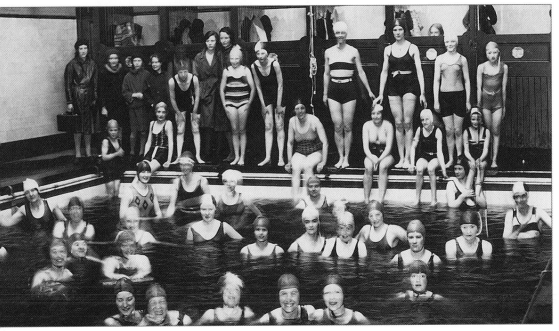

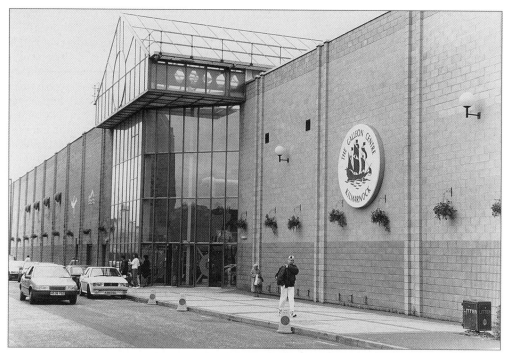

By the start of the 1980s there was a demand for a replacement swimming pool and additional recreational facilities. The result was the Galleon Leisure Centre, named after the Gallion Burn in the vicinity but spelled differently. This provided a new swimming pool, along with sports courts, ice rink, bowling hall, a gymnasium and other facilities. The Galleon was built on the site of the Saxone shoe factory. (*S&UN*)

5

Kilmarnock at War

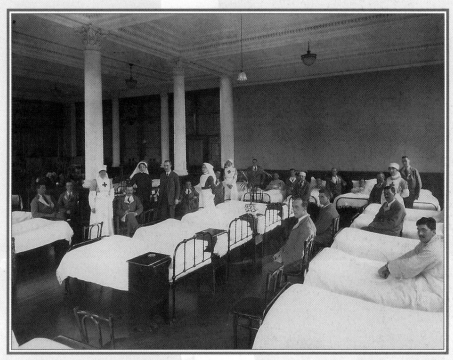

One of the rooms at the Dick Institute that formed part of the Red Cross auxiliary
hospital, 1917. War has an impact on towns and cities far from the battlefields.
Apart from the appalling death toll of the First World War, there were so many
injured soldiers that the hospitals could not cope. The library, museum and art
gallery in the Dick Institute were closed and the building handed over to the Red
Cross. During the Second World War Kilmarnock's engineering companies turned to
war work. It was a relatively easy move for firms like Andrew Barclay, Sons & Co.,
but more difficult for carpet-makers BMK, who started manufacturing shells. (*EAC*)

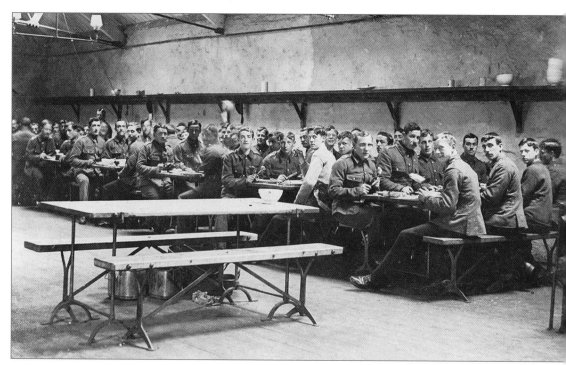

Men of the Black Watch at camp in Kilmarnock just before the First World War. As the war loomed the was a huge movement of men and training camps were set up all over the country. *(PC)*

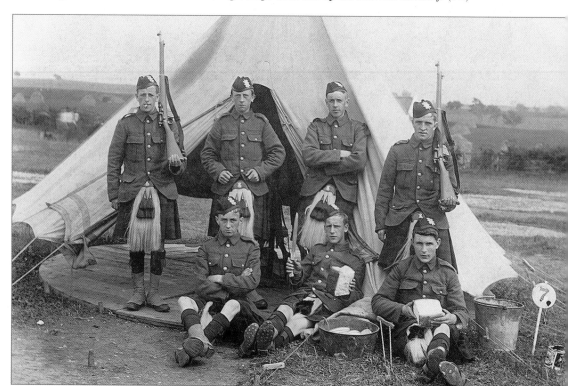

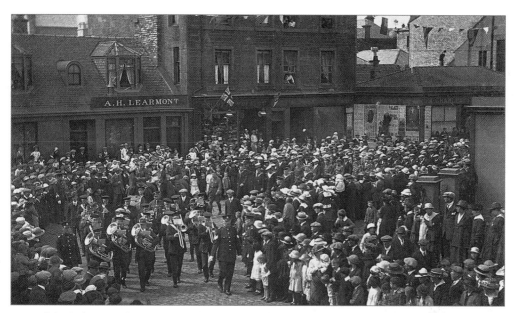

Part of the Kilmarnock peace parade, which culminated in celebrations at Howard Park after the end of the First World War. The First World War ended on 11 November 1918, but it was not until July 1919 that the country celebrated the peace. Here the parade is turning from King Street into Fowlds Street. (*PC*)

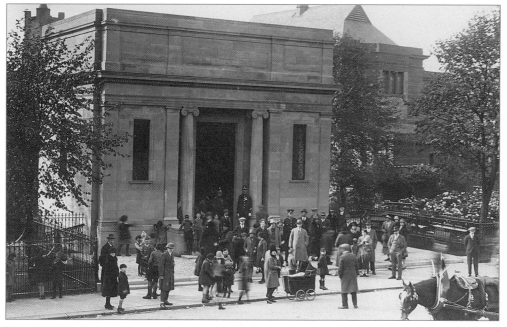

The opening of the Kilmarnock war memorial in 1927. It lists the local men killed in the 2 world wars – 900 of them. During the First World War, UK government policy was to put Scottish regiments into conflict areas before English regiments, a strategy that resulted in losses of Scottish soldiers being almost 25 per cent of combatants, as compared with the figure of 12 per cent for the UK. (*PC*)

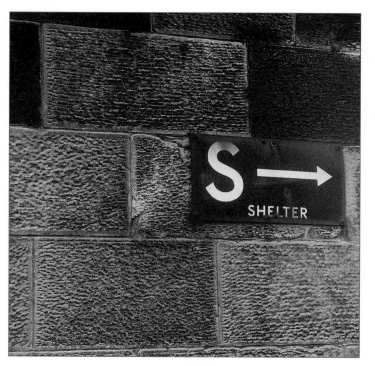

A Second World War sign directing you to an air-raid shelter. The First World War was a soldiers' war, but t Second World War affected civilians far more than any conflict before. A home people were involved in all sor of campaigns to save everything and to produce more food. At the start o the war, children were evacuated fr the cities, gas masks were issued to everyone and public air-raid shelters were set up everywhere. Clydebank suffered some of the heaviest bombin of any British community, with more than 1,000 deaths and only 8 of 12,000 homes left undamaged. It wa on the night of one of the Clydebank blitz raids that a stray German plane dropped bombs on nearby Kilmarno killing four inhabitants. (*FB*)

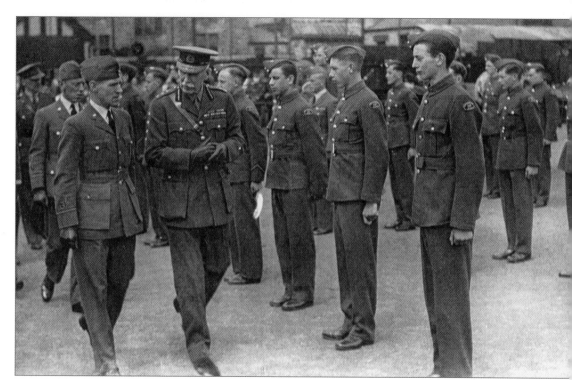

An inspection of the men of the local Air Training Corps, Second World War. Such visits by VIPs we common and helped boost the morale of those based at home or still in training. (*Author's Collection*)

orkers at the armaments factory at Bowhouse, *c.* 1942. After the war the site lay derelict for many years it is now occupied by Scotland's only privately run prison. (*Author's Collection*)

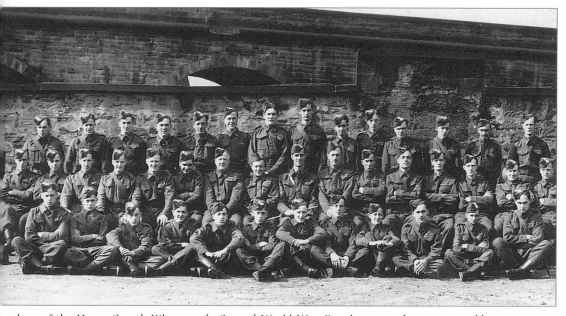

embers of the Home Guard, Kilmarnock, Second World War. For the men who were too old or too young go to war or those in reserved occupations, such as the mines, there was always the Home Guard. These en did have an important role to play, not just in keeping up morale, but in doing work that might herwise have been done by regular soldiers. (*Author's Collection*)

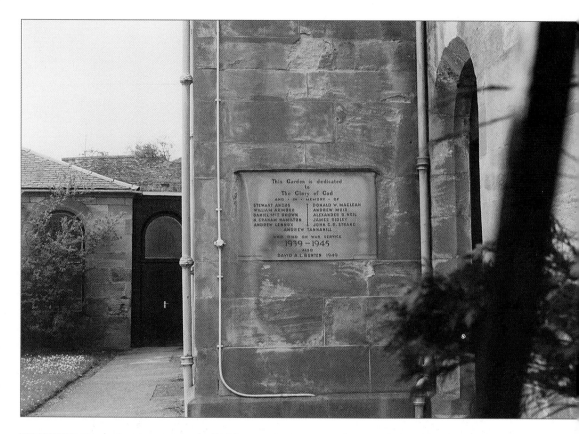

As with the end of the First World War, there were many casualties of the Second World War and local people felt that their names should be remembered. Memorial plaques naming the victims of both conflicts are still on view in churches, schools and other public buildings. This stone on the West High Church was removed recently and placed in the wall of the Laigh West High Kirk. (*FB*)

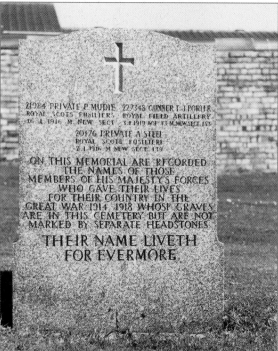

This memorial stone in the local cemetery tells its own story, listing the names of men buried there but who do not have their own headstones. (*FB*)

6

Transport

The steps at Struthers on the River Irvine between Kilmarnock and Hurlford, late
nineteenth century. Before there were any cars, trams or trains, most people walked
to wherever they had to go. In many cases rivers had to be crossed by a ford or by
stepping stones. These steps have long since been removed but the name Struthers'
Steps lives on. (*EAC*)

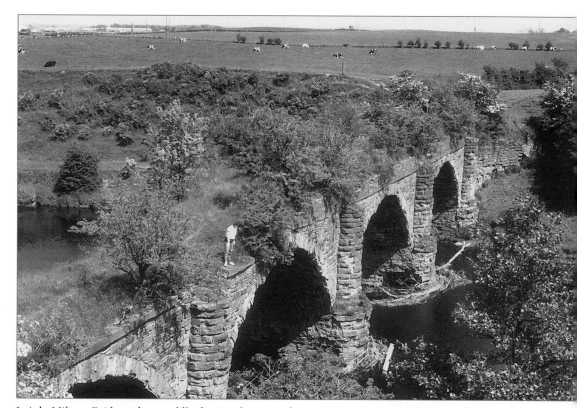

Laigh Milton Bridge, the world's first railway viaduct, 1980s. Railways became the first form of mass transport, allowing many people to travel more widely than ever before. The first railway in Scotland was the Kilmarnock & Troon Railway. Although built for coal, it had a regular passenger service from 1812. This line also contains the disused viaduct seen here; it has now been restored. (*FB*)

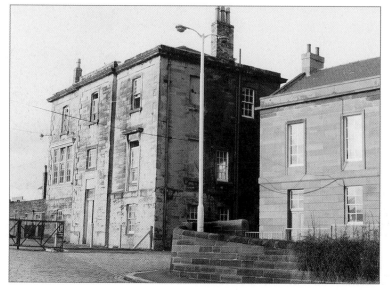

The station house of the Glasgow, Paisley, Kilmarnock & Ayr Railway. This line was built in 1843 and was soon extended to Dumfries, and quickly became part of a growing national network. In 1995 the old station building was controversially demolished. (*FB*)

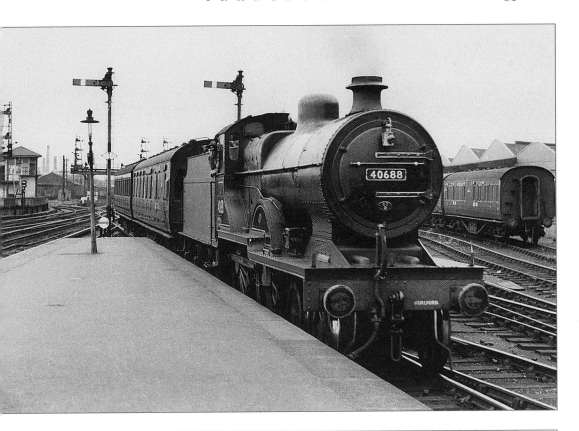

lmarnock station, *c.* 1960.
lmarnock had become an
nportant railway town with
rious companies involved in
comotive building and
sociated engineering. The
wn's station was frequently busy
ith steam locomotives. (*S&UN*)

ne departure of the last train
om Kilmarnock to Ardrossan
n 11 April 1964. The railways
ominated transport in the
neteenth century and for the
st half of the twentieth century.
early every town and village
ad a railway station or access to
ne via a bus service. But in the
cond half of the century new
osperity saw a boom in private-
r ownership and a decline in
ie use of railways. The result
as the Beeching report which
rought about the closure of
any stations and lines. (*S&UN*)

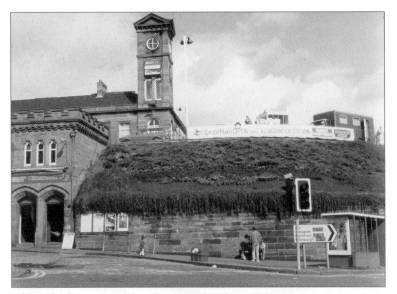

Kilmarnock railway station is a lot quieter today than in years gone by. Its distinctive building has changed little since the photograph on the left was taken in 1988, although a floral clock has been added to the grounds. (*FB*)

The interior of the station. The Victorian feel remains, assisted by the iron pillars and glass roof. Some of the brackets on the pillars have a unique pattern with the letters G&SWR intertwined. This was the Glasgow & South Western Railway, which greatly extended the earlier station of the Glasgow, Paisley, Kilmarnock & Ayr Railway Company. (*S&UN*)

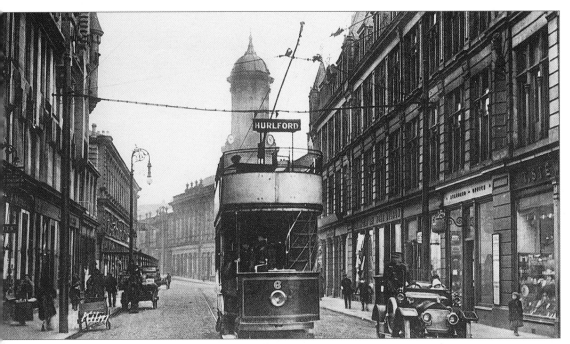

The decision to introduce a tram system in Kilmarnock was controversial, but the promise of getting a public electricity supply with it proved too good an offer to resist. The system operated from 1904 to 1926, but it offered a limited service with only fourteen cars, and it was never a financial success. The photograph above shows tram No. 6 in Duke Street, heading for Hurlford. The photograph below shows tram No. 3 at Glencairn Square, heading for the Cross. Both images were taken soon after the system opened. (Above: *PC*; below: *Author's Collection*)

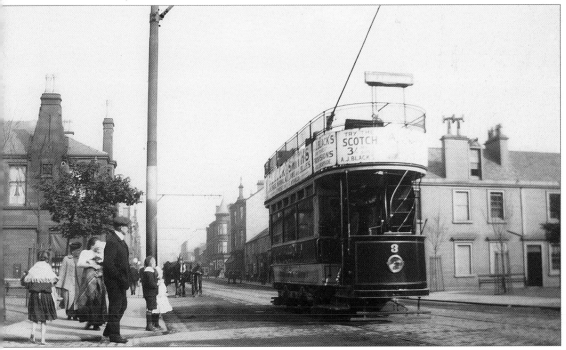

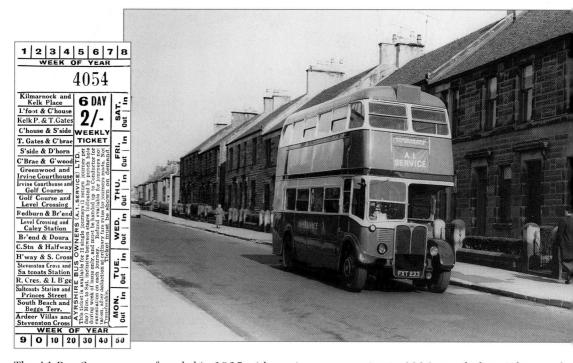

1	2	3	4	5	6	7	8

WEEK OF YEAR

4054

Kilmarnock and Kelk Place	6 DAY			
L'foot & C'house	**2/-**	SAT.	Out	In
Kelk P. & T.Gates				
C'house & S'side	WEEKLY			
T. Gates & C'brae	TICKET			
S'side & D'horn		FRI.	Out	In
C'Brae & G'wood				
Greenwood and Irvine Courthouse				
Irvine Courthouse and Golf Course		THU.	Out	In
Golf Course and Level Crossing				
Redburn & Br'end		WED.	Out	In
Level Crossing and Caley Station				
Br'end & Doura				
C.Stn & Halfway		TUE.	Out	In
H'way & S. Cross				
Stevenson Cross and Sa'tcoats Station				
R. Cres. & I. B'ge		MON.	Out	In
Saltcoats Station and Princes Street				
South Beach and Beggs Terr.				
Ardeer Villas and Stevenston Cross				

WEEK OF YEAR

9	0	10	20	30	40	50

(vertical text in ticket: AYRSHIRE BUS OWNERS (A.I.SERVICE) LTD. This ticket is available for 12 single journeys (1 return journey per day) Mon. to Sat. inclusive between stages indicated by punch hole during week of issue only, and must be handed up to Conductor for cancellation on each journey. Refund available for journeys not taken, after deduction at ordinary fare rates for journeys made. Not Transferable. Ticket must be shown on demand)

The A1 Bus Company was founded in 1925 with services commencing in 1926, mostly from Kilmarnock
Irvine and Ardrossan. The company consisted of a number of semi-independent operators working togethe
Above is a typical 1950s scene with an earlier ticket (inset) showing some of the stops on the way. Th
photograph below shows the A1 bus station at Croft Street shortly before it moved to a shared bus station
1974. In 1995 A1 became part of Stagecoach. (Above: *CM*; below: *FB*)

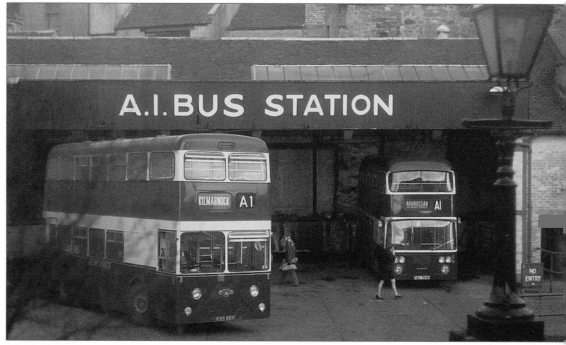

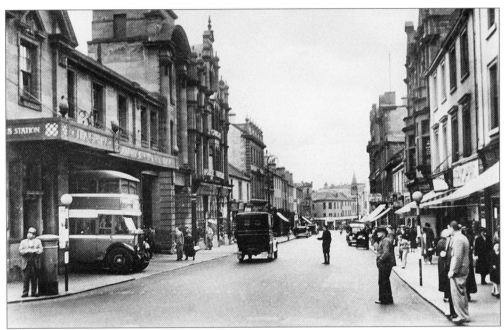

In 1897 Dick Brothers started operating the first motor bus service in Kilmarnock on the route to Hurlford, but it was not until 1926 and the closure of the tram system that bus transport really took off in the area. In 1931 the town sold their bus interests to the General Transport Company (later Western SMT) which had a main depot and maintenance works in Kilmarnock. The Portland Street bus station seen in the 1936 photograph above (or transport station to give it its proper title) was opened in 1924. It served the town until a new shared bus station, seen in the photograph below (from about 1998), was opened at the Foregate, serving both the Western SMT and A1 companies. It is attached to the Burns Shopping Mall. Western is now part of Stagecoach of Perth. (Above: *PC*; below: *S&UN*)

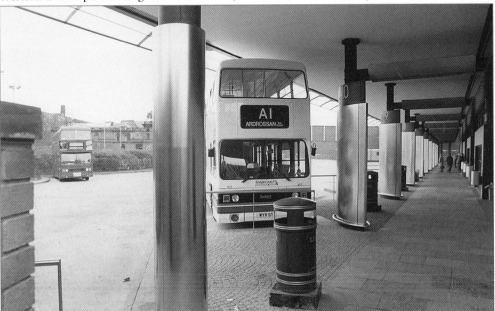

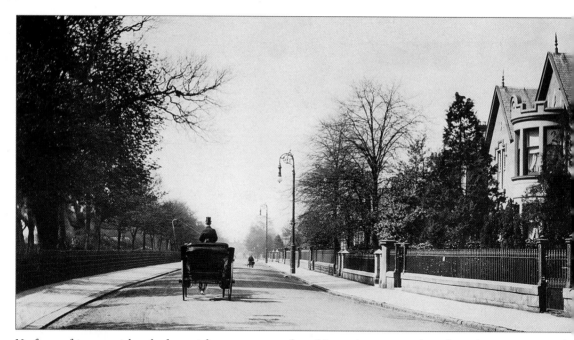

No form of transport has had a quicker or more profound impact on our society than the motor car. It ha
allowed centralisation of all sorts of services and indirectly encouraged the growth of out-of-town shoppin
The photograph above shows Dundonald Road at the end of the era of horse-drawn traffic in about 190
The recent photograph below shows congestion on the totally inadequate A77 'killer road' from Kilmarno
to Glasgow. Because of the appalling accident record on this road, local residents have fought and won
campaign to have a motorway built between Kilmarnock and Glasgow. Work was due to start in 200
(*Above: PC; below: S&UN*)

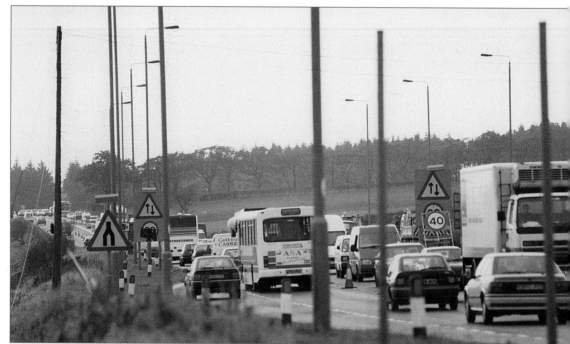

7

Cottages & Castles

The Walker Buildings in Hood Street. In 1658 the houses of the town were described as 'ugly' and little better than huts. It wasn't until the start of the nineteenth century that builders were compelled to use slate on the roofs of new houses. There was no council housing until after the First World War. In the nineteenth and early twentieth century, many large businesses provided homes for employees. The Walker Buildings were erected in 1904 for workers of the world-famous Johnnie Walker whisky company. Their design was unique, but they were controversially demolished to make way for a retail park. (*FB*)

Little remains today of Craigie Castle, another of the properties once owned by the Wallace family. It used to be one of the most magnificent castles in Ayrshire, but as times changed and the needs of the ruling class altered, so too did their homes. In about 1600, Craigie Castle was abandoned in favour of the castle at Newton-upon-Ayr. (*FB*)

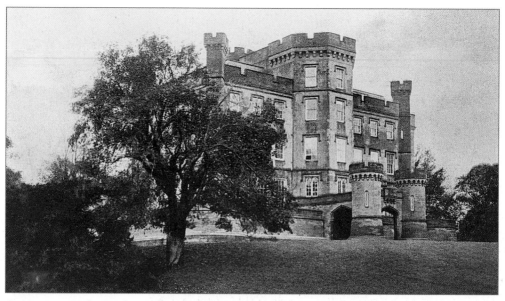

Caprington Castle, on the southern edge of Kilmarnock, is mentioned in a charter dated 1385. At one time it belonged to the Wallace family but as early as 1462 it was in the possession of the Cunninghame family, who still own it today. Many alterations to the building have been made over the centuries and the façade of the castle seen today is the work of architect Patrick Wilson, who reconstructed Caprington Castle in 1829. (*PC*)

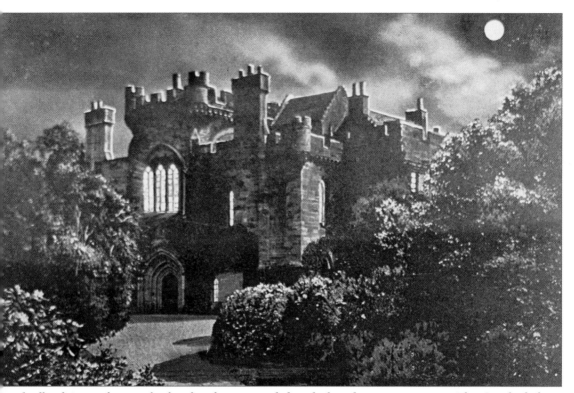

raufurdland is another castle that has been extended and altered at various times. The Craufurds have ccupied the castle since the start of the thirteenth century. The present structure shows three distinct hases of construction. The oldest part of the castle is the central portion, while the reconstructed Gothic ntrance is relatively modern, having been built in 1825. The section to the left of this dates from 1648 and hat to right from the fifteenth or sixteenth century. (*PC*)

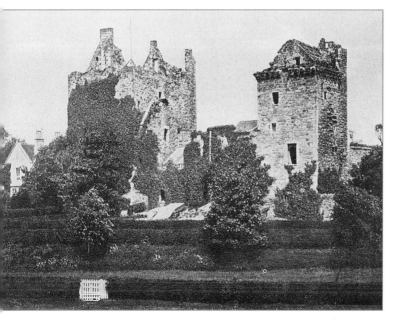

Dean Castle, *c.* 1905. This is the best known of the local castles and is a popular tourist attraction today. Until about 1700 the castle was known as Kilmarnock Castle. The keep, on the right of the picture, dates from the fouteenth century and the palace from the fifteenth century. It was the home of the Boyd family until it was seriously damaged by fire in 1735. Restoration started in the twentieth century and in 1975 the castle was given to the people of the town along with important collections of early musical instruments and armour. (*PC*)

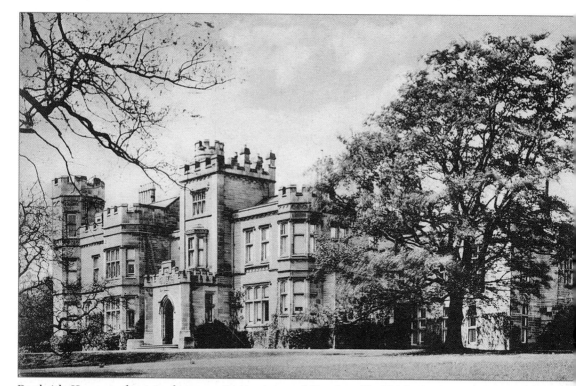

Dankeith House and estate, between Symington and Dundonald, 1904. For centuries the Kelso fami
owned this old property and it was rebuilt in 1893. Part of the original building was retained at the rear
the structure. When the Second World War broke out, Dankeith House was requisitioned by the RAF a
because of its relative seclusion was an ideal venue for high-level conferences. It was here that sever
meetings were held to plan details of the D-Day invasion and of the Allied landings in North Africa. At t
end of the war the estate passed to the Passionate Fathers, who used it as a training centre for Catho
priests between about 1948 and 1968. Dankeith then became a caravan park with the main building bei
used as offices. (PC)

Mount House, on the edge
of Kilmarnock, 1997. This
fine property was built in
1793 as a private residence
and served as such until
1950, when it came on the
market. It was bought by
Kilmarnock Town Council
and quickly converted for
use as a home for the
elderly. By 1996, however,
it was felt that the facilities
there were no longer of a
high enough standard. The
establishment was closed
and the property eventually
sold. (FB)

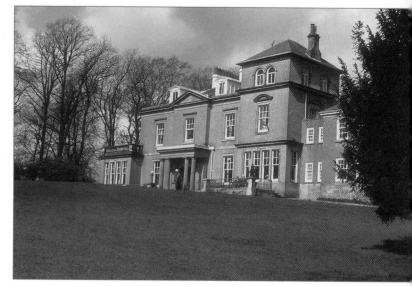

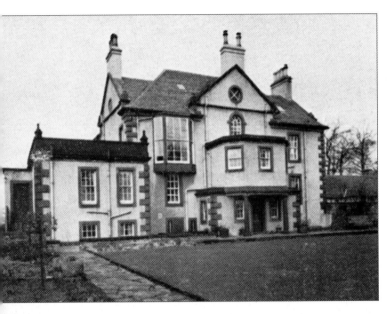

Braehead House, 1962. This is a fine example of a mid-eighteenth-century mansion house and was built for the Paterson family in about 1761. The first Paterson who occupied the house may have been Robert, who was a lawyer, or his son, William, who was town clerk. Robert Burns was friendly with the family and during one visit he scratched some lines of poetry on the glass panel of a window. The house was demolished in 1965, but the window-pane was preserved and is just one of many items in the local museum collection that has national significance. (*EAC*)

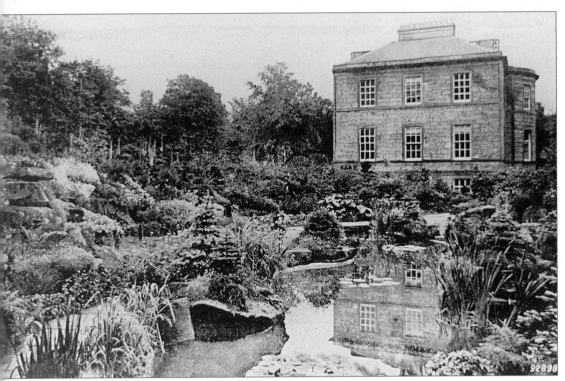

ellfield House in Kilmarnock, *c.* 1930. Three unmarried daughters of a wealthy Glasgow businessman, eorge Buchanan, lived here – Margaret, Jane and Elizabeth. When the last of the three daughters died, the ouse and the 250 acres of ground were given to the town along with a generous bequest and a well-ocked library. The house and grounds were opened to the public in 1888 and quickly became a favourite ace for locals to visit for walks or teas. The house was demolished in 1969 and 1,800 houses were built the estate, although a substantial part of the grounds remain as a public park. (*PC*)

Humble homes are every bit as important to the social historian as impressive castles. These two houses were probably built in the early nineteenth century. The photograph above shows a property in Bentwick Street. The one below shows a building in the same area of the town in James Little Street. Neither of the houses survives today. (*EAC*)

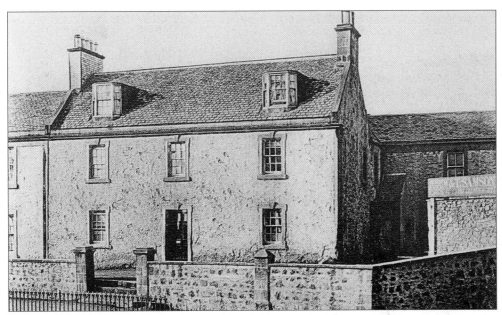

Tam Samson's home in London Road, *c*. 1905. Tam was born in 1722 and in 1759 started a business supplying seeds and other merchandise to the farmers of Ayrshire. Later the business incorporated nurseries. He became a friend of farmer-poet Robert Burns and is immortalised in his work. The seed business continued until 1984. With its links with Burns, the Samson family home in London Road was classed as a historic monument, but, despite widespread protests, it was demolished in the 1960s. (*PC*)

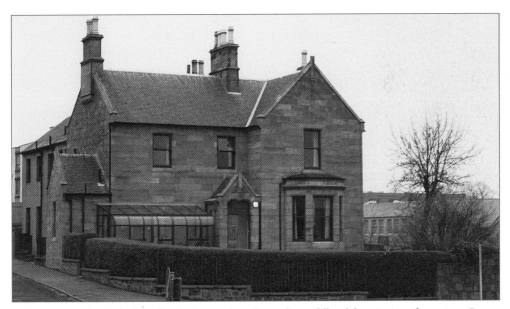

Originally called Bellsford Bank, this house dates from the middle of the nineteenth century. It was built as a private residence, probably for the Paxton family, who owned a nearby brewery and Richardland House. After changes of ownership the house came into the possession of Kilmarnock Town Council, who opened it as a children's home in 1950. It is still in use today. (*FB*)

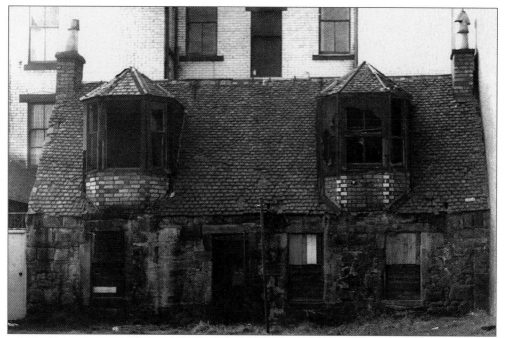

Dilapidated cottages in St Andrew Street. This was one of the older streets of the town and in the eighteenth century was known as 'the back road'. The properties seen here no longer exist. (*EAC*)

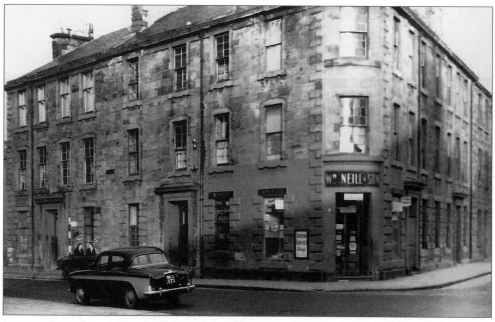

Tenements at the corner of Fowlds Street and Princes Street, *c.* 1955. In the years after the Second World War there was a desperate need for new housing. To compound the issue, many of the older tenements were no longer suitable. Throughout the 1950s and 1960s there was a massive programme of building at Shortlees and Bellfield, and many town-centre homes, now classed as slums, were cleared away. (*EAC*)

The 3,000th house to be built by Kilmarnock Town Council at McKinlay Place, completed in 1939. Council housing began to be constructed in earnest in the years after the First World War with the policy of building 'homes fit for heroes'. Soon whole streets of council-owned houses were available at affordable rents. (*FB*)

Samson Avenue, part of an area of council housing built on land that was once a nursery run by Tam Samson, 1978. One of the last provosts of Kilmarnock was Annie Mackie and this commemorative lamp-post remains outside the house she occupied at the time she held office (1971–4). It was customary before local government reform in the 1970s for two lamp-posts to be erected outside the home of the provost. When he or she gave up office one of the lamps was removed. (*FB*)

Tenements in North Hamilton Street, 1980. These flats were built in 1883 and are still known as
Cheeny Buildings because they were constructed with locally made white glazed 'cheeny' bricks. One of
properties contains a commemorative brick bearing the date of construction, but no other details. (*FB*)

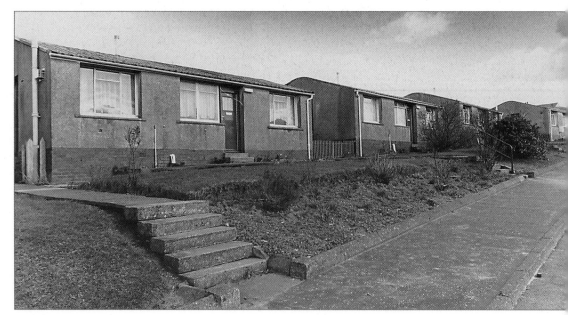

Prefab houses at Broomhill Quadrant, 1994. During and immediately after the Second World War there w
a desperate need for houses and an equally desperate shortage of materials and manpower. The solution w
to construct houses using parts prefabricated in factories. They quickly came to be known as 'prefabs' a
became part of popular culture. More than 250 prefabs were built in Kilmarnock, mostly in Altonh
Burnpark and Hillhead. Although intended to be temporary, some have been reinforced with bricks and a
still occupied today. (*S&UN*)

8

At Your Service

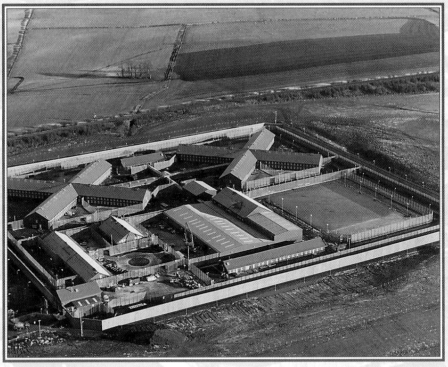

Scotland's only privately operated prison, at Bowhouse, a former munitions factory, 1999. Over the years, local authorities have been responsible for a wide variety of services, including lighting, cleaning, education, health, emergency care and the provision of transport, communication and other facilities. Some services at times provided by a local authority, such as gas and electricity, have been nationalised and later privatised. Like many towns, Kilmarnock at one time had its own jail, run by the local authority, but this was closed in 1880. (*SPS*)

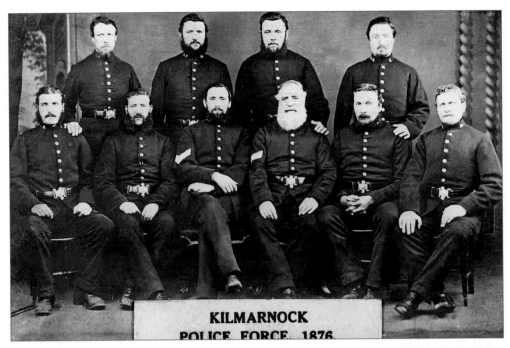

KILMARNOCK
POLICE FORCE, 1876.

The fine body of men seen in the photograph above represented the Kilmarnock Burgh Police in 1876. The first move to appoint individuals and members of the military volunteers to police the streets of Kilmarnock came after a series of attempted break-ins in 1800. They were apparently called out only when required. In 1828 the library in the town hall was converted into a police office and in 1898 the police office, seen below in 1904, was opened. In 1968, the Kilmarnock Burgh Police, the Ayr Burgh Police and Ayrshire Constabulary were merged. Today they form part of Strathclyde Police, the second largest force in the UK. New premises were needed and the police office seen here was demolished in 1973. (Above: *EAC*; below: *PC*)

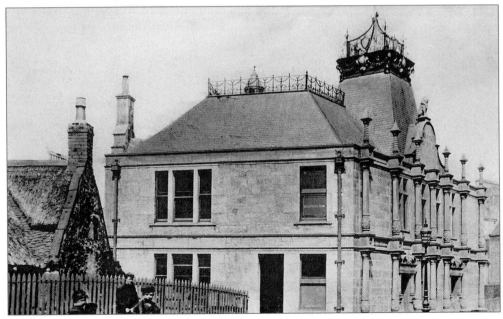

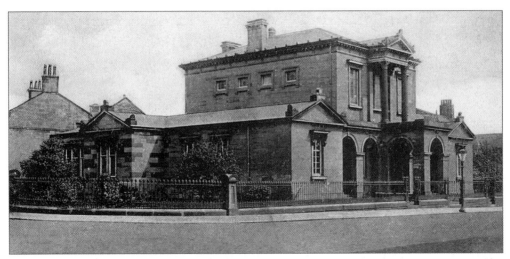

The sheriff court house, opened in 1852, seen here in 1904. Dealing with those accused of crimes is an age-old problem. Until the middle of the nineteenth century most minor offences in Kilmarnock were settled by local magistrates, while the more serious crimes went before a sheriff in Ayr. In 1846 Kilmarnock had a sheriff, but no sheriff court house. Kilmarnock had one sheriff until 1975, when a second permanent sheriff was appointed. Since 1983 the district has had three permanent sheriffs. Today the building seen here is used for the procurator fiscal's office and there is a new sheriff court house across the road, which is also used for sittings of the High Court. (PC)

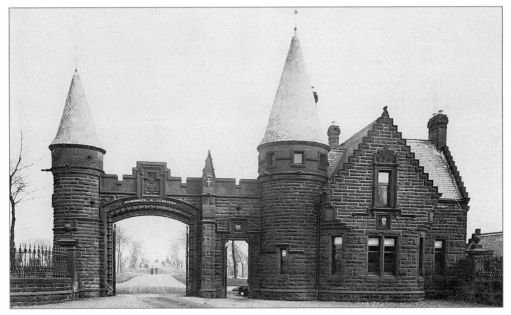

The Gothic gatehouse and lodge of the cemetery in Grassyards Road, c. 1910. Responsibility for the disposal of the dead lay with the church until the nineteenth century. In 1875 the town cemetery was opened. Within five years there had been 2,000 interments. In 1892 land adjacent to the original plot was acquired for an extension. In 2002 Scotland's first green burial site was opened at Midland Farm just outside Kilmarnock by a private company. (PC)

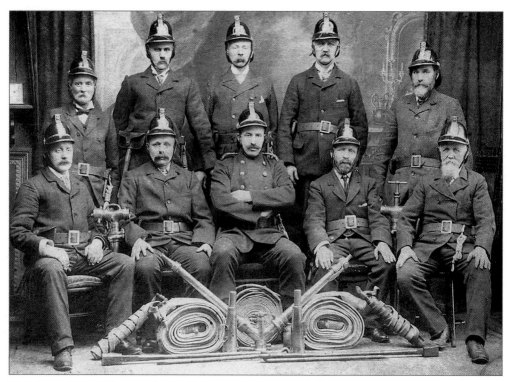

Members of the Kilmarnock Fire Brigade at the end of the nineteenth century. Formed in 1863, the brigade had an engine shed at Green Street. In 1896 an additional fire station was opened at Calcutta Lodge in Titchfield Street. In 1937 a site adjacent to Calcutta Lodge became the area's new fire station. Today's headquarters is at Campbell Street, and was opened in 1994. (*Author's Collection*)

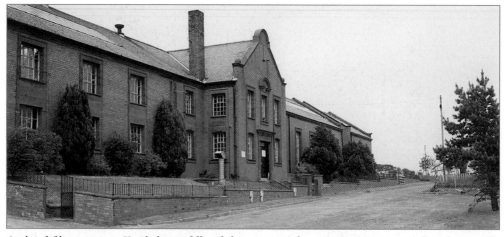

Amlaird filter station. Until the middle of the nineteenth century water was taken from wells and rivers, but in 1846 powers were obtained to allow the formation of a Kilmarnock Water Company to provide piped water to the town. It was finally formed in 1850, the year that also saw the first use of Gainford and North Craig as reservoirs. The company assets were purchased by the town in 1891 and the filter station seen here was opened in 1901. It was rebuilt in 2000. (*FB*)

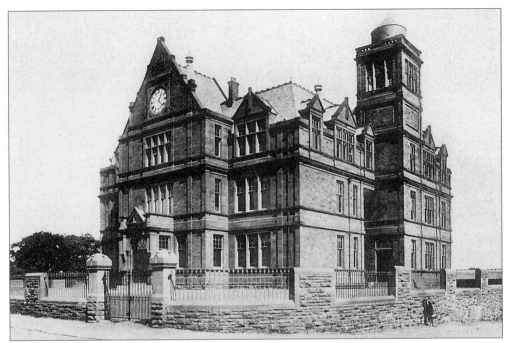

Kilmarnock Academy, 1898. In 1633 the Scottish Government passed a law requiring that there should be a school in every parish in the country. Other schools existed, of course, and in 1808 the burgh school and the parish school were amalgamated to form Kilmarnock Academy. The building seen here was erected in 1898 and the odd structure on the square tower probably protects the school's astronomical equipment. In the nineteenth century the Academy was unusual in that it was the only school in Ayrshire where astronomy was treated as a serious subject for study. (*PC*)

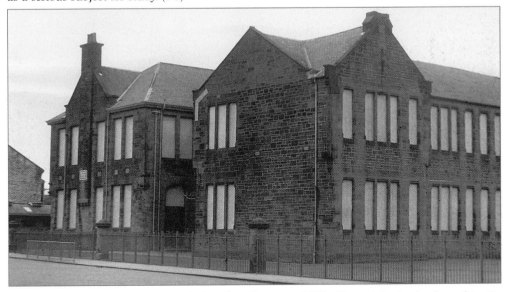

Bentinck Primary School, shortly before demolition in 1979. The original school on this site was the Kay School, one of two provided for the town by Alexander Kay in 1869. From humble local origins, Kay made a fortune in insurance. His other local legacy is Kay Park. (*FB*)

A new Act of Parliament was passed in 1810 which gave various powers to the burgh of Kilmarnock, including street lighting. At this ti lights were provided by hanging baskets of burning straw from poles, such as the one seen above. This piece of local history was demolishe in January 2003, more than a century after it was last used. In 1792 William Murdoch of Auchinleck gave demonstrations of how coal ga could be used for lighting. In 1822 the Kilmarnock Gas Company was formed to supply the town with gas. They raised enough money allow their works to be built the following year. 1871 the political and commercial climate had changed and the Kilmarnock Gas Company wa bought by the town. Growing demand meant th there were frequent extensions and alterations the plant. Services were nationalised in 1949. T use of electricity followed a similar pattern. The Kilmarnock Electric Club was founded in 1857. Some businesses had electric power, provided by their own generators, but in 1904 the town supplied it. It remained in local control until nationalisation. Today the generation of electric in Ayrshire is at Hunterston Nuclear Power Station but plans are well advanced for a major wind farm at Whitelee Forest near Fenwick. The photograph below shows the electric power station on the right and the gas holder in the centre, surrounded by cattle and trees. (Above: *FB*; below: *EAC*)

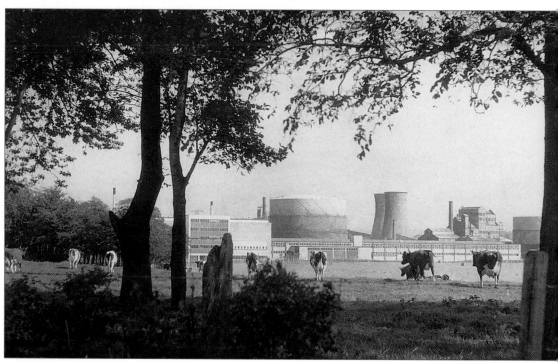

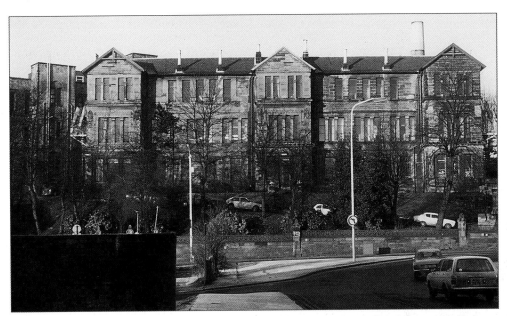

Kilmarnock Infirmary, *c.* 1985. This hospital was opened at Mount Pleasant in Wellington Street largely with the help of public subscriptions. It admitted 101 patients in 1869 and 420 in 1878. It was extended on several occasions and closed in 1982 when Crosshouse Hospital was opened as a replacement. The infirmary site has been derelict since 1994 but is now earmarked for housing. (*FB*)

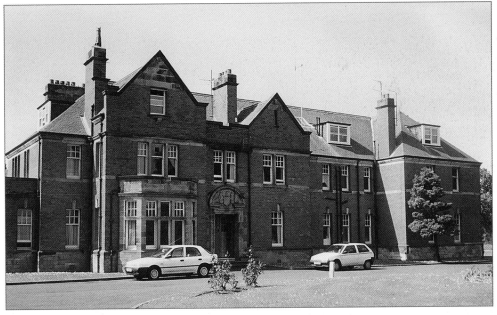

Kirklandside, 1994. Kilmarnock Infirmary was the main hospital for the town, but there were others, also run by the local authority. Kirklandside was opened as a hospital for patients with communicable diseases in 1909. In keeping with the theories of the time about infection, this establishment was at a suitable distance from the town. There were extensions of responsibilities in 1917 and 1920. Today it is used for convalescent patients. (*FB*)

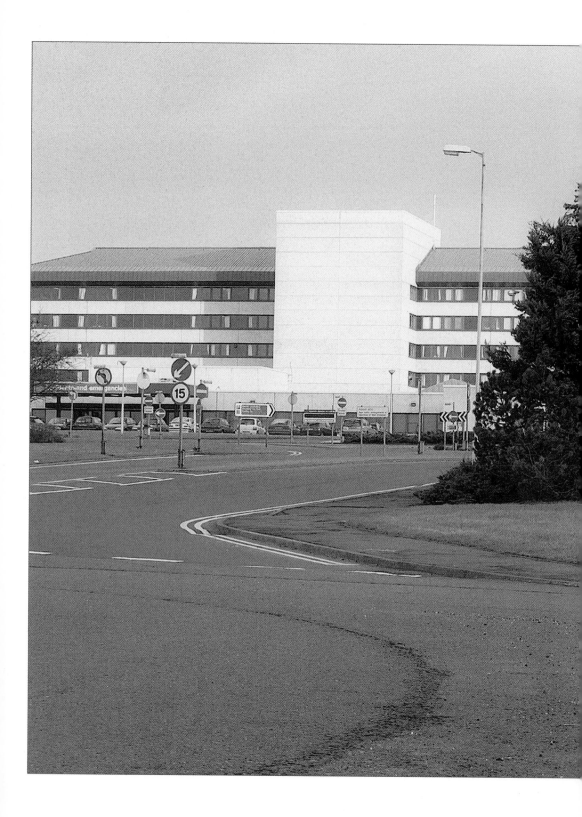

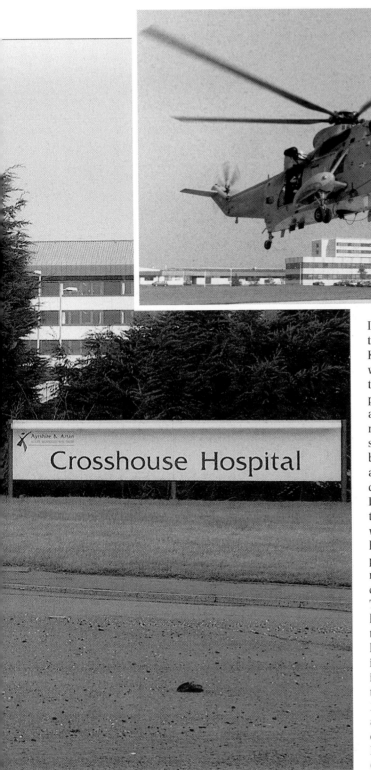

In 1935 it was recognised that there was a need to replace Kilmarnock Infirmary. Various sites were investigated, but the onset of the Second World War delayed all plans. After the war little happened as adjustments were made to the new NHS system. By 1963, the search was resumed for a new site, but it took until 1973 for work actually to start. There were further delays and the new North Ayrshire District General Hospital (NADGH) took its first patients in 1982. There were new facilities, such as a heliport, which is seen in the photograph above. The NADGH name was so unpopular it was changed to Crosshouse Hospital. The flat roof caused problems and had to be replaced with a traditional peaked roof. The hospital has had some success, however, including Scotland's first cochlea implant performed in 1988 by a team headed by Dr Raj Singh. In 2003, a major refurbishment began and maternity services, previously dealt with at Ayrshire Central Hospital, will be added to Crosshouse in 2005. (S&UN)

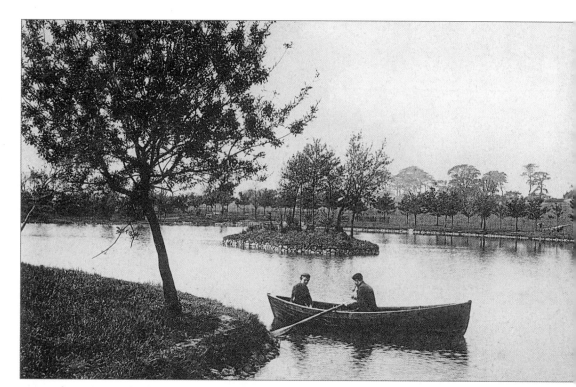

Kay Park was created in the name of Alexander Kay. The park was opened in 1879 and continues to be
popular place for walks and leisure activities. These photographs show the boating lake in 1902 and orna
fountain and bandstand in 1904. While the pond is still there, the bandstand and fountain were remov
during the Second World War. (*PC*)

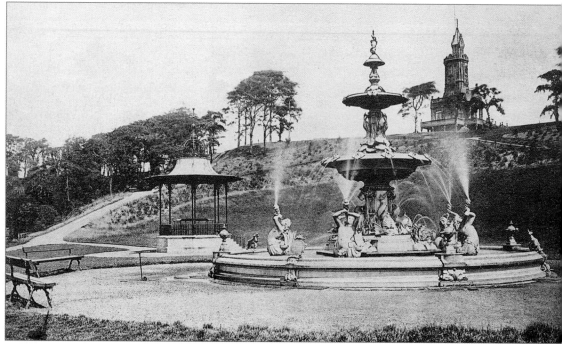

ɔward Park was originally called Barbadoes Green and was the grounds of Kilmarnock House. The land as given to the town for use as a park and was opened as such in 1894. The Lady's Walk, seen in the ɪotograph above in 1924, is named after Lady Kilmarnock who is said to have frequently walked the area hile waiting for news of her husband's trial in London. Having taken part in the Jacobite Rebellion, he was ed for treason and executed in London in 1746. The photograph below, taken in 1904, shows the ɔnument to Dr Alexander Marshall, who gave more than forty years' service to the town. (*PC*)

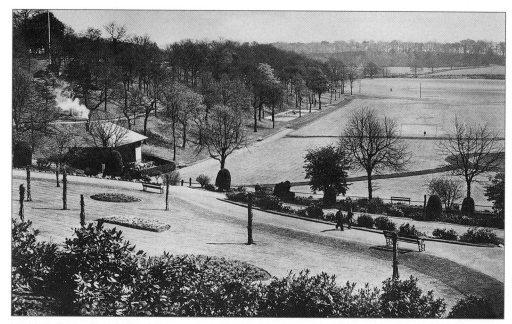

Dean Park, in the north of the town, 1955. In 1907 Lord Howard de Walden gifted this land to Kilmarnock. Long before it was a public park, this area had been used for public meetings, in particular the Reformers' gatherings. In 1816, 4,000 people attended one such event, which advocated democracy. The ringleaders were charged with sedition. (*PC*)

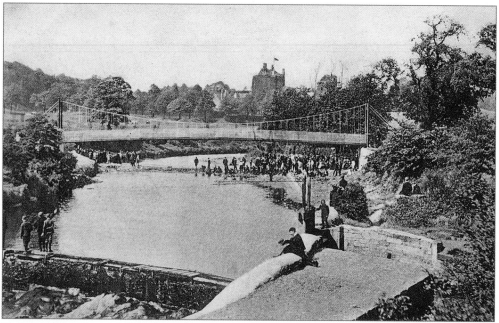

The Lauder Bridge, near Dean Park, 1905. It was opened on 3 June 1905, but so many people wanted to be among the first to cross it that the suspension cables snapped and the bridge collapsed into the river. It was soon replaced. (*PC*)

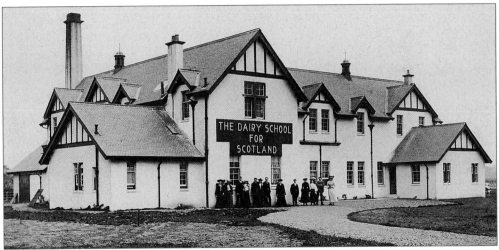

The Dairy School for Scotland, 1907. The Scottish Dairy Institute was formed in Kilmarnock in 1889 when various dairy associations in the south-west of Scotland were amalgamated. The institute immediately set about turning part of Holmes Farm into an agricultural school. It later became the Dairy School for Scotland. In 1899 it joined with a newly formed agricultural college. There was a major expansion in 1904, but still there was not enough room and in 1937 the Dairy School for Scotland moved from Kilmarnock to Auchencruive, near Ayr. The Kilmarnock building became a maternity home with thirty-two beds. (*PC*)

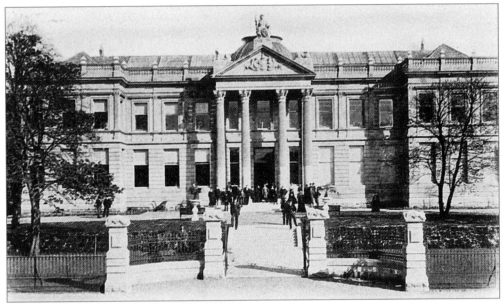

The Dick Institute, 1901. The cultural hub of the Kilmarnock area is the Dick Institute, which is in the care of East Ayrshire Council. It serves as a library, art gallery and museum. The town's first public library was founded in 1797, but a hundred years later it was felt that a centre combining the arts, a library and a museum was desirable. The money came from James Dick, a Kilmarnock man then mining in Australia. By luck, the request for funding arrived on the day he discovered a major seam of gold. The building was opened in 1901, seriously damaged by fire in 1909 and re-opened in 1911. (*PC*)

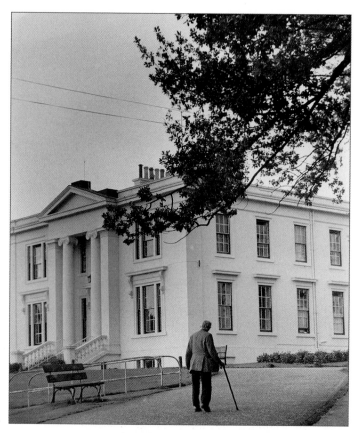

Springhill House, 1984. The care of the elderly is something that is split between family, community, social workers and the private sector. In Kilmarnock the local authority opened the town's first eventide home – or old people's home – in 1945 at Springhill House. The mansion had been built in about 1840 and was the home of coalmasters, the Finnie family. In 1966 sheltered houses in the grounds of Springhill House were officially opened by Willie Ross MP and named Springhill Gardens. (S&UN)

Mill Court, 1990. By 1987 needs and attitudes had changed and in Kilmarnock the newest privately operated sheltered housing scheme was opened at Mill Court by the Hanover (Scotland) Housing Association. It provided thirty flats and an on-site warden; all apartments were connected to the warden's property. (FB)

9

Churches

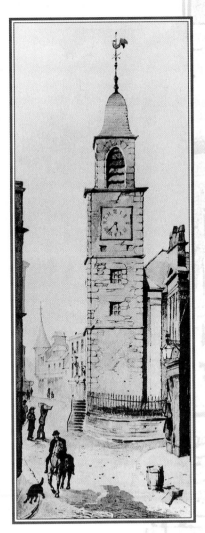

Laigh Kirk. Kilmarnock began with a church, one dedicated to St Marnock, or Mhearnog, the nephew of St Columba who first brought Christianity to Scotland from Ireland. That first church was probably established close to the site now occupied by the town's most senior church. Originally, it was known just as the church, then when the population had grown so much that a second church was required, it became the Laigh Kirk. Now with amalgamations its official, if ugly name, is the Laigh West High. In pre-Reformation days, it was a church of Rome, but with the Reformation it became part of the Church of Scotland. It has been part of many turbulent times. When Charles II decided that as king he was the head of the church in Scotland, the people resisted. The penalty for worshipping outwith his system was summary execution. The freedom fighters were the Covenanters and in the kirkyard around the Laigh Kirk you will find stones in memory of those who gave their lives for this cause. Even today, the church maintains that God, and not a monarch, is the head of the church. In 1801, disaster devastated the congregation of this church. Fearing the roof was collapsing, which it was not, people stampeded to get out and thirty died in the mayhem. The church was rebuilt in 1802 and it is that building which serves the congregation today. (*Author's Collection*)

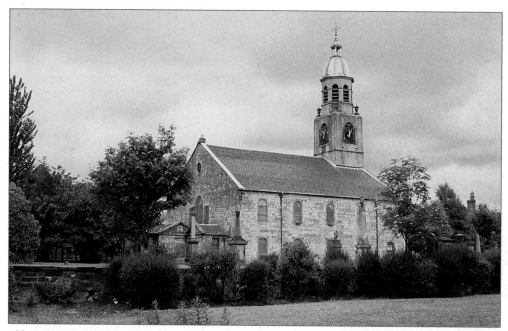

Old High Kirk. This is the second church in Kilmarnock and work began on its construction in 1731. Until 1764, this church shared ministers with the older Laigh Kirk. In the churchyard there are gravestones marking the resting places of several prominent citizens, including Thomas Kennedy, the inventor of the water meter; John Wilson, printer and publisher; Thomas Morton, engineer; and the Tannock brothers, artists. (*FB*)

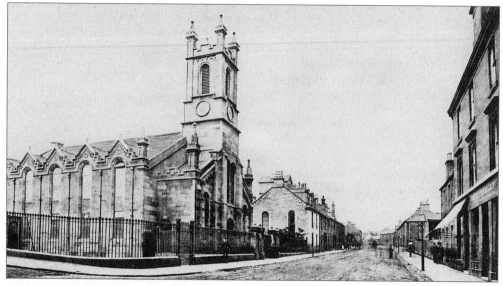

West High Church. The year 1843 is generally referred to as 'The Disruption in the Church of Scotland'. The church split and the Free Church was established. In the following year about 500 churches were built, including the West High Church. In 2000 the congregations of the West High Church and the Laigh Kirk agreed to merge and transfer all worship to the older building. (*PC*)

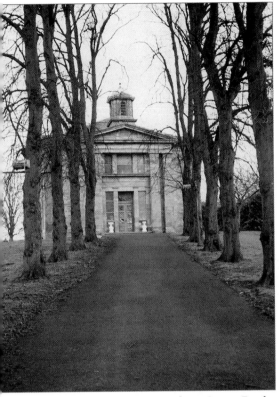

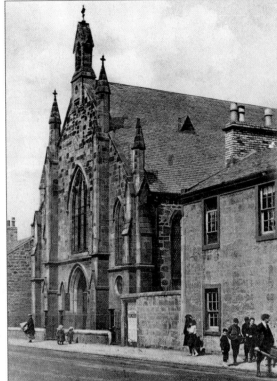

St Andrew's Church, built in St Andrew Street. By the time construction work started in 1839, there was already a burial ground around the site. In 1890 the congregation of St Andrew's Church held a grand bazaar and raised £800 for erecting a church hall. In 1967 the congregations of Glencairn and St Andrew's churches united under the title of St Andrew's Glencairn. In 2002 the church closed. (FB)

Glencairn Church. Built in busy Glencairn Square in 1881, the church replaced an earlier mission on the same site and that in turn replaced an earlier one just across the road. Following the merger of Glencairn Church and St Andrew's Church in 1967, the building seen here was demolished in 1993. (PC)

The laying of the foundation stone of Henderson Church, 1906. Like so many other churches in Scotland, Henderson Church can trace its origins to disputes. Following a split with the Gallows Knowe Church in 1818, the Henderson Church was established in Wellington Street. The congregation dwindled until the charismatic Revd David Landsborough was appointed and revived the congregation to the extent that a new building was required. It opened for worship in 1907. (PC)

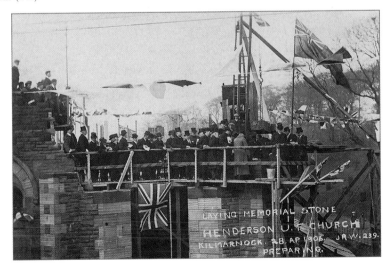

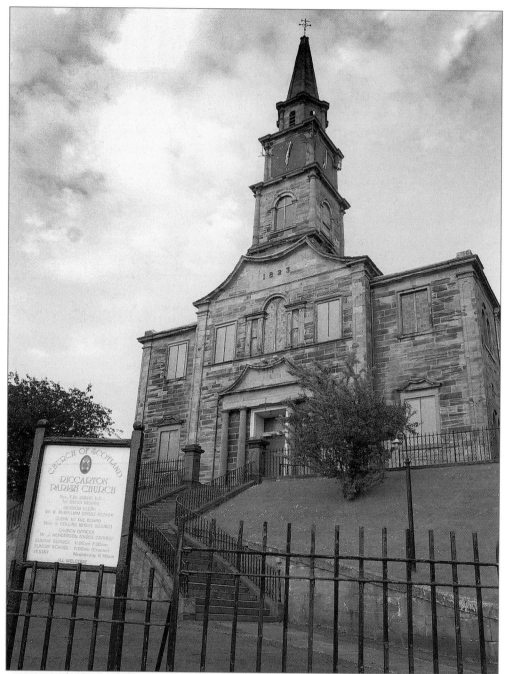

Riccarton Church. Riccarton was once a separate village and a separate parish. As such it had its own church and there is evidence of a church in Riccarton as early as 1229. The building seen here is said by some to have been erected on an ancient motte. Construction of the present building began in 1823 and the first Christian worship followed two years later. At the time of construction, the structure was encased in scaffolding and a local character called Sandy McCrone climbed to the top and stuck a potato on the beak of the weathercock to win a bet. Sandy terrified his friends by doing this at night . . . and because he was blind. (S&UN)

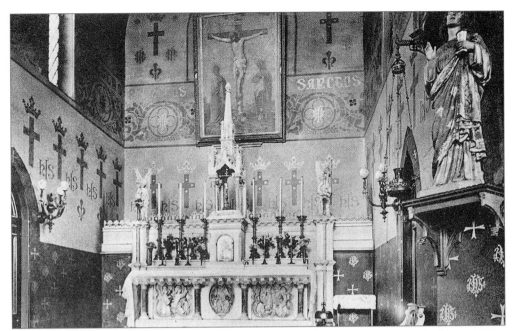

The interior of St Joseph's, Hill Street, 1913. After the Reformation there was no Catholic church in Kilmarnock, but by the middle of the nineteenth century there was a large enough Catholic population to construct one. St Joseph's was built near the railway station in 1847. Today, there is a strong argument for making the Kilmarnock church a cathedral. (*PC*)

The English Church on the corner of Dundonald Road and Portland Road, 1905. The name of this church is misleading and its correct name is in fact the Holy Trinity Scottish Episcopalian Church. It was built in 1857. (*PC*)

Clerk's Lane Church, 1907. In 1775 a new church was established at Clerk's Lane with the Revd Jam
Robertson as the minister. It was soon too small for the needs of a growing congregation and w
demolished to make way for a larger building. This church lasted until 1911, when it became the Electr
Theatre, the first Kilmarnock cinema. In 1938 the cinema closed and the building was demolished. (PC)

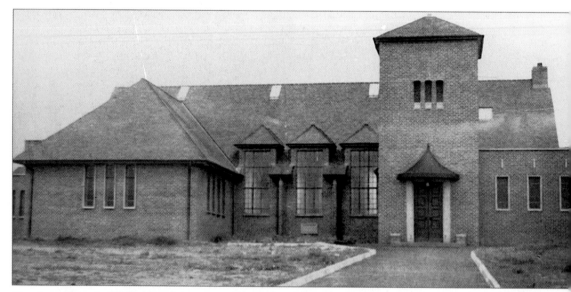

Shortlees Church, 1953. In order to meet the needs of the population in the immediate post-war period va
housing schemes such as Shortlees were developed. To serve this particular area a new church was buil
Shortlees Church, designed to match the austerity of the time, was opened in 1953. Today it shares i
minister with the neighbouring housing area of Bellfield. (PC)

10

Achievers

Robert Burns. Kilmarnock has produced and influenced many writers and artists, but none is more important than Robert Burns (1759–96). He was never the peasant poet portrayed by some. He was a farmer and well educated. Burns was born in Alloway and when he was farming at Mosgiel he came into the market at Kilmarnock to sell his produce and buy supplies. He charmed everyone with his sharp wit and satirical poems but shocked some with his ideas of democracy and a brotherhood of man. Burns is important to the story of Kilmarnock and Kilmarnock is significant in his own life. It was in Kilmarnock that Burns found many friends and much inspiration; it was to Kilmarnock he looked for a printer for his poems. The World Burns Federation was founded in Kilmarnock and continues to have its head office in the town. Each club has its own number – London is club No. 1, Kilmarnock is club No. 0. (*S&UN*)

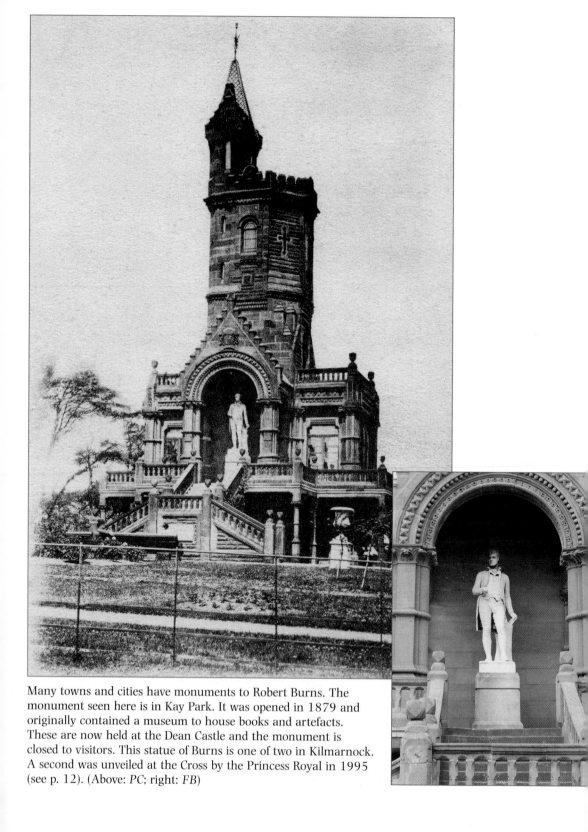

Many towns and cities have monuments to Robert Burns. The monument seen here is in Kay Park. It was opened in 1879 and originally contained a museum to house books and artefacts. These are now held at the Dean Castle and the monument is closed to visitors. This statue of Burns is one of two in Kilmarnock. A second was unveiled at the Cross by the Princess Royal in 1995 (see p. 12). (Above: *PC*; right: *FB*)

ERECTED BY
THE AYRSHIRE ASSOCIATION
OF BURNS CLUBS
TO MARK THE SITE OF
THE PRINTING OFFICE
FROM WHICH THE FIRST EDITION
OF THE POEMS OF
ROBERT BURNS
WAS PUBLISHED JULY 1786

JULY 1947

John Wilson was born in 1759, the same year as Robert Burns. He established a book shop in Kilmarnock and in about 1783 took over the printing works of Peter McArthur. In 1786 Wilson published the works of Burns, creating the now valuable Kilmarnock Edition. In 1790 he took his press to Ayr and began newspaper production. This stone is now in the Burns Shopping Mall. (*S&UN*)

Kilmarnock's monument to the reformers who campaigned for democracy which was unveiled in 1885. Democracy is a relatively new idea in this country. At the start of the nineteenth century there was a long and bitter struggle to win the right to vote. Those who advocated democracy were often shipped off to the colonies. Of course, after voting rights had been conceded, the establishment proclaimed that it had been a good idea all along and the pioneers were heroes instead of villains. (*PC*)

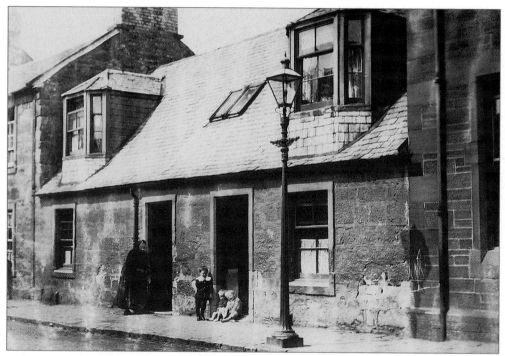

Alexander Smith earned a national reputation as a fine poet and author. He was born in the cottage seen above, in Douglas Street, when the roof was still made of thatch. Lack of work forced the family to move from Kilmarnock when Alexander was still a child, but some years later they were able to return. By 1854 his reputation was such that he was made secretary to the University of Edinburgh. His brilliant career was cut short by typhoid and he died at the age of just thirty-seven in 1867. The stone seen below marks the site of the cottage where he was born. (Above: *EAC*; below: *FB*)

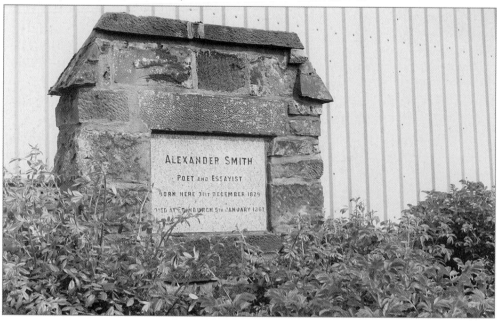

Kilmarnock's monument to the victims of the war between Abkhazia and Georgia, 1992–3. Kilmarnock was the first town in the UK to be twinned with a town in the USSR. This was the city of Sukhumi, now called Sukhum in Abkhazia. With the disintegration of the USSR, Georgia broke away from Russia and Abkhazia from Georgia. (*FB*)

Local resident Malky McCormick, a rebel who has the reputation of being one of the country's top cartoonists. He is always in demand for commercial and promotional work, but it is political satire that he excels at, using his sharp wit and sharp pencils to deride royalty, politicians and anyone else who deserves to be taken down a peg or two. (*S&UN*)

Reid's Hotel in Funchal on the island of Madeira wa
opened in 1891 as one of the most luxurious hotels
in the world. Today, as Reid's Palace Hotel, it
maintains that reputation, and yet this establishmer
was founded by William Reid, the local man who lef
Ayrshire as a teenager with just a few pounds in his
pocket, but a lot of determination. (*Reid's Hotel*)

Duncan McMillan (1817–66), ventriloquist. As a bo
McMillan learned the art of ventriloquism and
eventually gave up his job as a weaver to become a
professional entertainer. He lived in Bentinck Street,
but toured all over Britain. His act included
impersonations and making his voice appear from a
sorts of odd places. He was generally regarded as
being one of the top ventriloquists in the country.
(*EAC*)

'The Victor' by David McGill, the war memorial in Kilmarnock. McGill was born in Maybole and brought up in Kilmarnock. He earned a high reputation as an excellent sculptor and examples of his work are on display across the country. His statue 'Renunciation' is housed in the foyer of the Dick Institute. (*PC*)

A 1999 UK postage stamp showing a penicillin mould. Nobel prize winner Sir Alexander Fleming was born in Darvel and attended Kilmarnock Academy for his secondary education. The discovery of penicillin was just one of his achievements, but it has had the most profound impact on health in the twentieth century. (*Courtesy of Consignia Heritage*)

The Temperance Queen, Kilmarnock, 1953. The temperance movement in Kilmarnock started early in the nineteenth century and grew and withered with time. It was strong from the 1930s through to the 1950s. During that period an annual temperance queen contest was held. (*PC*)

ACKNOWLEDGEMENTS

I would like to thank the following for their help and for permission to use photographs:

Kilmarnock Standard, Ayrshire Post, Irvine Herald.

Bank of Scotland; Burniston Studios, Greenock; Consignia Heritage; East Ayrshire Council, Museum, Arts and Theatre Services; Messrs Johnnie Walker; Scottish Prison Service.

Mike Bisset, James Brown, John Caldwell, Sandy Ferguson, Tom Ferguson, Hugh Fulton, Norman Gee, James Knox, Helen MacDougall, Derry Martin, C. Mitchell, Bob Murray, James Page, W. Scholes.

I am also grateful for contributions to the book from three people who have died recently. They are John Hall, Allister MacPherson and Gordon Robb.

I have used the following abbreviations in the picture credits at the end of each caption:

BoS: Halifax-Bank of Scotland; CM: Mr C. Mitchell; DN: Derry Martin; EAC: East Ayrshire Council, Museum, Arts and Theatre Services; FB: picture by Frank Beattie; HM: Helen MacDougall; JB: James Brown; JC: John Caldwell; JH: John Hall, Stewarton; JW: Johnnie Walker & Co.; JMcG: John McGill, Kilmarnock; PC: commercial postcard in the Author's Collection; RM: Robert Murray; S&UN: Scottish & Universal Newspapers (*Kilmarnock Standard, Ayrshire Post* and *Irvine Herald*; various photographers: Mike Bisset, Albert Brown, Sandy Ferguson, Stewart McLauchlan, Allister MacPherson, James Page, Gordon Robb); SPS: Scottish Prison Service; TF: Tom Ferguson; WS: Mr W. Scholes.

BIBLIOGRAPHY
& OTHER SOURCES

Adamson, Archibald. *Rambles Round Kilmarnock*, Standard Office, 1875

Anon. 'A Famous Kilmarnock Engineer', first published in the *Kilmarnock Standard*, 1880

Barr, James. *The Scottish Covenanters*, John Smith, 1946

Boyd, William. *Education in Ayrshire Through Seven Centuries*, University of London Press, 1961

Boyle, Andrew. *Ayrshire Heritage*, Alloway Publishing, 1990

Brotchie, A.W. and Grieves, R.L. *Kilmarnock's Trams and Buses*, N.B. Traction, 1984

Deans, Brian. *Green Cars to Hurlford*, Scottish Tramway Museum Society, 1986

Gee, Norman. *Kilmarnock in Old Picture Postcards*, Vol. 2, European Library, 2002

Howieson, the Revd R.M. *Free St Andrew's, Kilmarnock, 1843–1943*, published by the Church, 1943

Hutton, Guthrie. *Mining: Ayrshire's Lost Industry*, Richard Stenlake, 1996

Kirk, Robert. *Pictorial History of Dundonald*, Alloway Publishing, 1989

Landsborough, the Revd David. *Contributions to Local History*, Standard Office, 1878

MacIntosh, John. *Ayrshire Nights' Entertainment*, Dunlop & Drennan, 1894

Mackay, James A. *Kilmarnock*, Alloway Publishing, 1992

McKay, Archibald and Findlay, William. *History of Kilmarnock*, Standard Office, 1909

Malkin, John. *Pictorial History of Kilmarnock*, Alloway Publishing, 1989

Munro, William. *Some Kilmarnock Celebrities*, *Kilmarnock Standard*, 1924

Paterson, James. *Autobiographical Reminiscences*, Maurice Ogle, 1871

Ramsay, John. *Gleamings of the Gloamin*, McKie & Drennan, 1876

Smellie, Thomas. *Sketches of Old Kilmarnock*, Dunlop & Drennan, 1898

Walker, James. *Old Kilmarnock*, D. Brown, 1895

OTHER SOURCES

Annals of the Kilmarnock Glenfield Ramblers, various years

Kilmarnock Chronicle

Kilmarnock Journal

Kilmarnock Standard

Kilmarnock Standard Annual, c. 1954–67

Newsletters of the Ayrshire Railway Preservation Group

Newsletters of the Kilmarnock and District History Group

Street and trade directories for Kilmarnock, 1833–1957